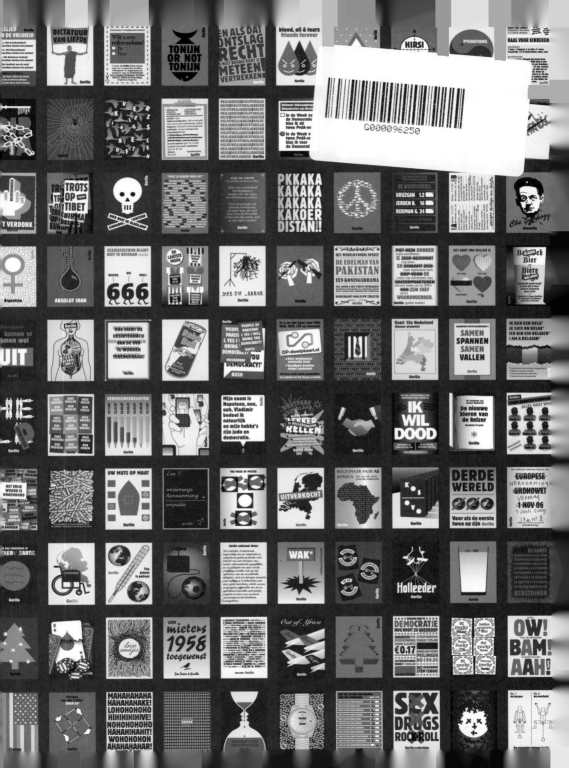

THE
DAILY
GORILLA
BY

Gorilla

BIS Publishers
Het Sieraad Building
Postjesweg 1
1057 DT Amsterdam
The Netherlands

T +31 (0)20 515 02 30
F +31 (0)20 515 02 39
bis@bispublishers.nl
www.bispublishers.nl

ISBN 978-90-6369-191-2

Printed in Singapore
Design by Gorilla, www.vk.nl/gorilla

THAT BOTTOM RIGHT CORNER

That was a difficult decision, in the late summer of 2006. Should Gorilla appear every day on the front page of de Volkskrant as the successor to the successful writers duo CaMu? De Volkskrant, after all, has a long and rich tradition of sharply written columns on page 1. Such illustrious men as Godfried Bomans, Hugo Brandt Corstius, Jan Blokker, Remco Campert and Jan Mulder have gathered a following here. And for them this tradition was verbal, just as the journalistic tradition is always a verbal one. But that is not the case with Gorilla. Gorilla belongs to the visual tradition. Providing a daily comment on the news, creating a smile every day, causing a frown, evoking a stimulating idea and doing this just by using a visual vocabulary. If that is your ambition, then you set yourself a heavy task. Yet that is precisely what the designers collective Gorilla have been doing. Since 2 October 2006. Every day, six times a week. Five graphic designers who shake the reader awake with a visual column in an area of five by eight centimetres. It has once been estimated that a poster in the street has precisely two seconds time to catch the viewer's attention. Two seconds, that's all. If the interest of the passer by has not been aroused in that time then the poster fails. The same laws apply to Gorilla. Gorilla is a poster. A good Gorilla grabs your attention at a glance and holds it. And you take a second look and a third, since a good Gorilla usually has extra details that are only revealed when you take a closer look. A flesh-coloured map of the Netherlands with the Betuwe Line drawn on it, but the railway has the shape of a scar. A proud Turkish flag, but the crescent is turned into a question mark. The shields logo of the embattled ABN Amrobank mixed up like

an origami puzzle. They are images we know, but not in this way. The images to which Gorilla are referring are stored in the gigantic image bank of our memory. And Gorilla is so clever at finding the right lever, the right association, to open this image bank. A drop of oil has the form of a tear expressing the grief of the Middle East, the Labour Party rose looks wilted and Wouter Bos is also having a hard time, the Socialist Party's tomato logo is looking rather bruised now that the party is suffering its first dents. We are able to place all these images because they are in fact clichés, but as clichés they are infused with a new life through a clever twist. I am a man of words, but my eye always goes avidly to that bottom right corner of de Volkskrant's front page. Is Gorilla angry, mocking, phlegmatic, jovial or amazed today? Almost always it's spot on, almost always it stirs something in me, with no words being used. Gorilla is a visual column. And there are precious few of them in the Netherlands. The makers do everything that columnists are supposed to do - they set the reader thinking, they seek the borderline, they tilt reality in such a way that you start looking differently at a familiar issue. Each day anew. That's a fine achievement. It makes Gorilla an important asset for Dutch journalism.

Pieter Broertjes
Editor-in-chief de Volkskrant

TABLE OF CONTENT BY

Gorilla

MUTUAL RECONSTUCTION

TALIBAN

ISAF

V.N.

C. RICE

BA'ATH

NEW LABOUR

IRAN

ISRAEL

WARLORDS

HOLY BIBLE

D. RUMSFELD

HOLY QURAN

NEOCONS

THE POPE

E.U.

PALESTINE

B. AL-ASSAD

SHIITES

SUNNIES

CHECHNIA

K. ANNAN

H. KAMP

RUSSIA

THORA

KNOW-IT-ALLS

SCEPTICS

Gorilla

24 OCTOBER

KOFI RULES

UNITED NATIONS DAY

JAN WAS
HERE

Gorilla SUCKS

OUR EARTH
OUR CHILDREN'S EARTH
OUR CHILDREN'S CHILDREN'S EARTH

Gorilla

HERE RESTS, AFTER ENDLESS AND USELESS SUFFERING

IRAQ

1932 - 2006

Gorilla

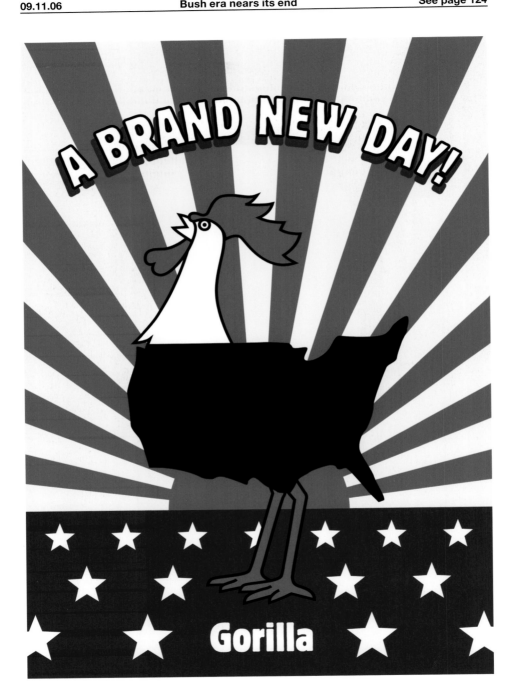

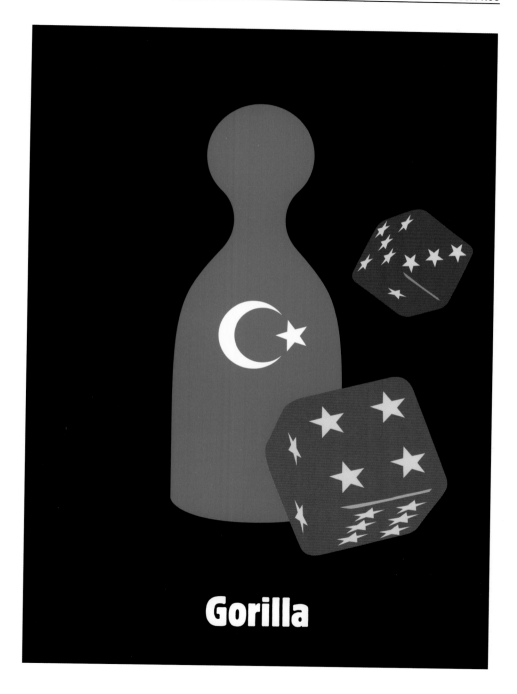

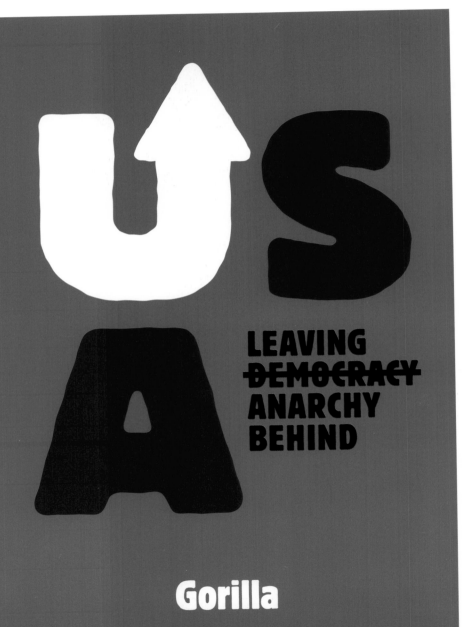

WAR IS OVER!

IF YOU WANT IT

John & Yoko & Gorilla

Taken away from us

Pinochet

* Valparaíso, 25 November 1915
† Santiago, 10 December 2006

After a long, well-spent and industrious
life, trusting in God, has passed away
he who, during his life, meant so much
to many, husband, father, grandfather,
father-in-law and murderer of
at least 3,000 political opponents,
faithful ally of Ronald Reagan
and Margaret Thatcher,
never prosecuted for his crimes,
Augusto Jose Ramon Pinochet Ugarte.

Gorilla

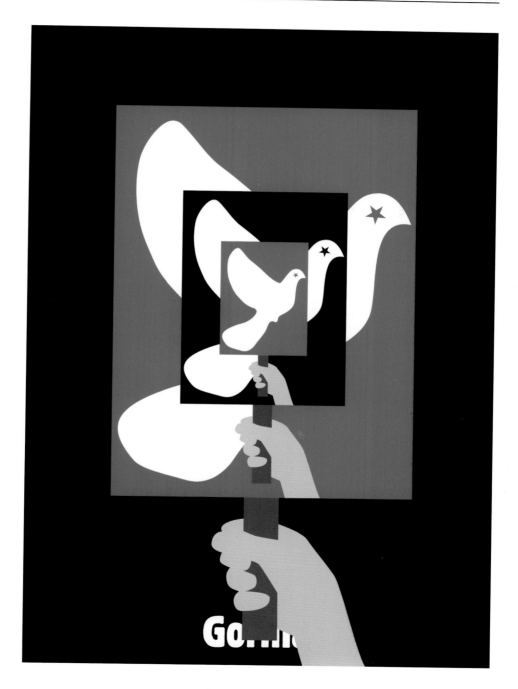

WARHUN
GERWARHUNG
ERWARHUNGERWA
RHUNGERWARHUN
GERWARHUNGERWAR
HUNGERWARHUNGERW
ARHUNGERWA
RHUNGERW
ARHUNGE
RHUNGER
WARHUN R
WARHU E
RWAR

Gorilla

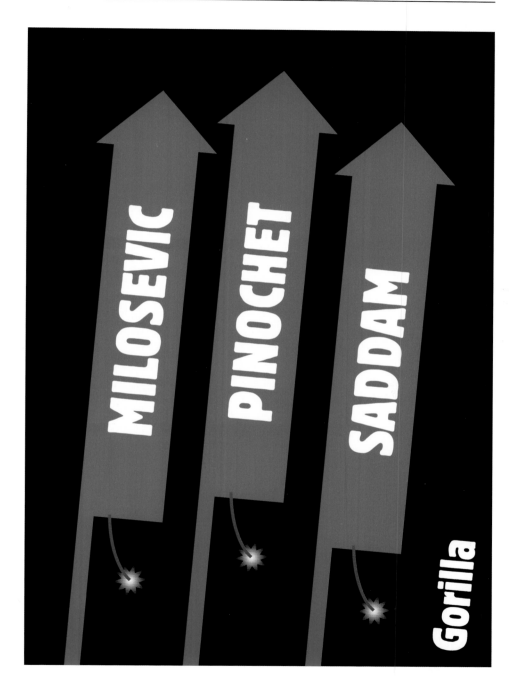

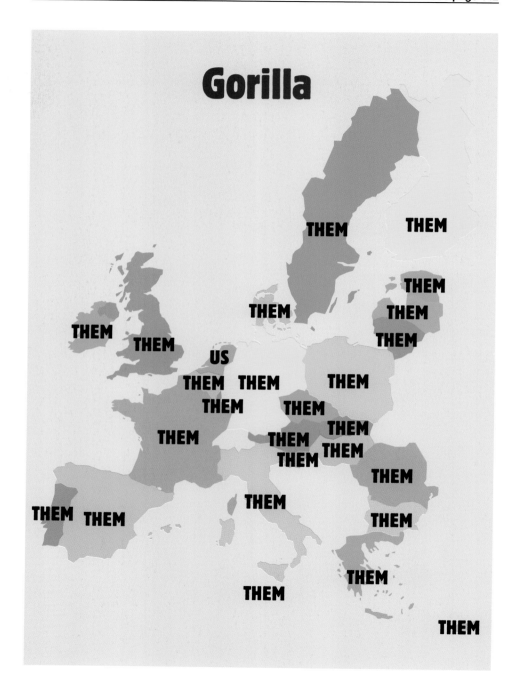

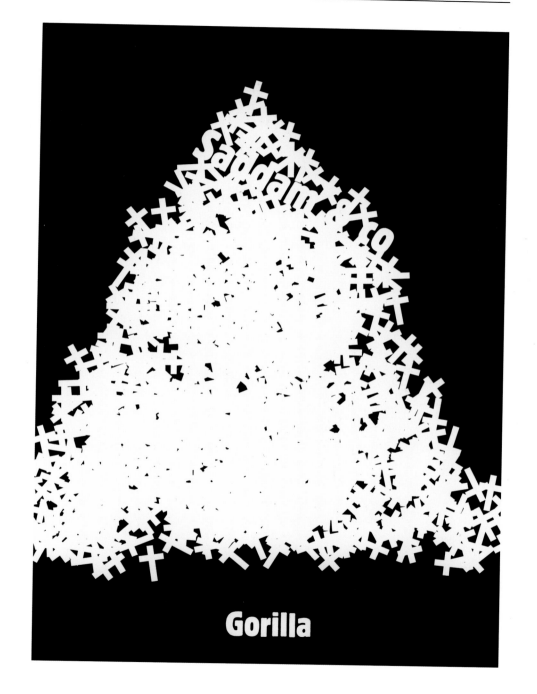

Are you lonesome tonight?

Elvis
08/01/35
16/08/77

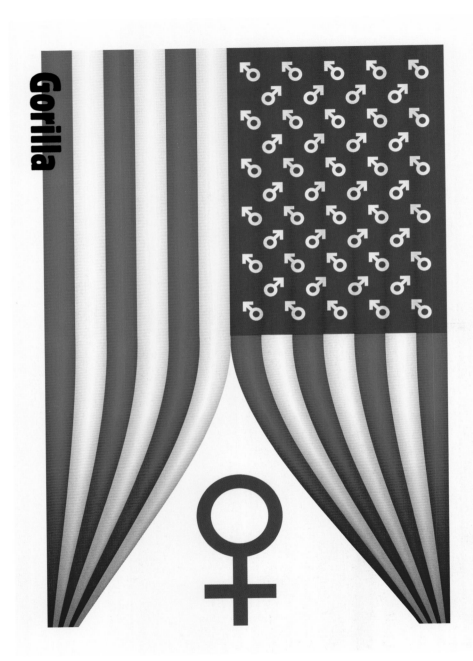

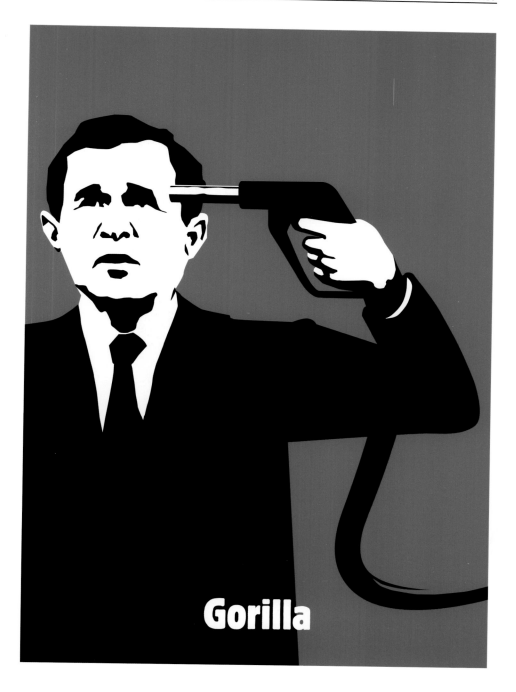

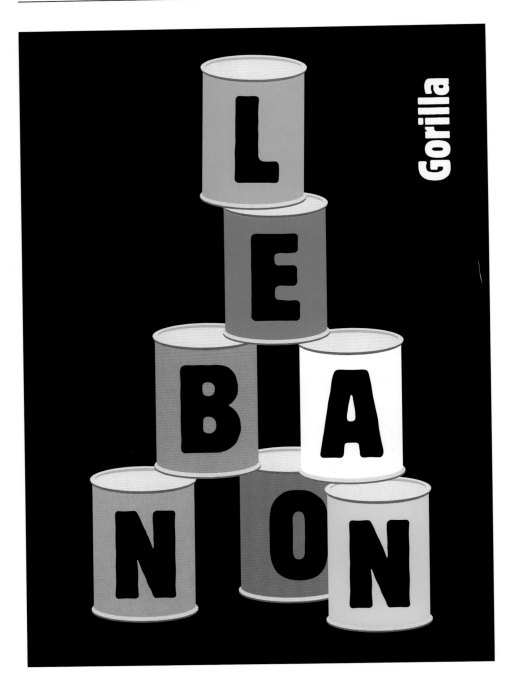

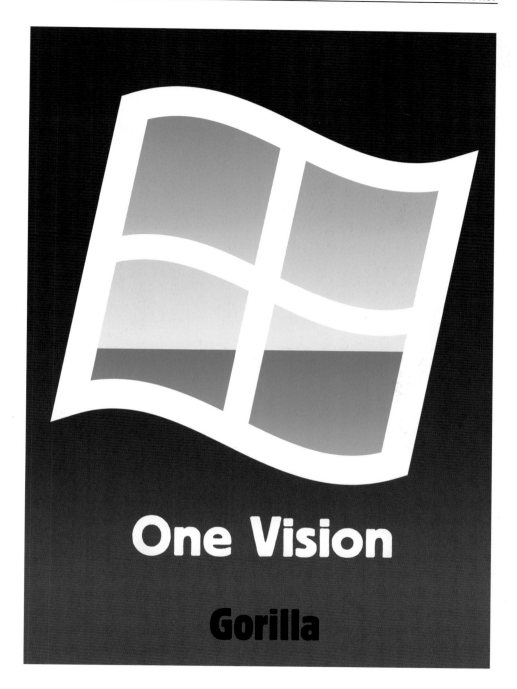

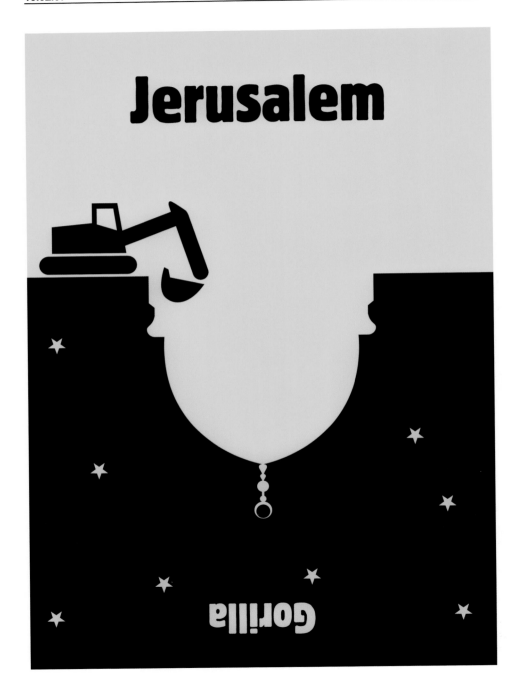

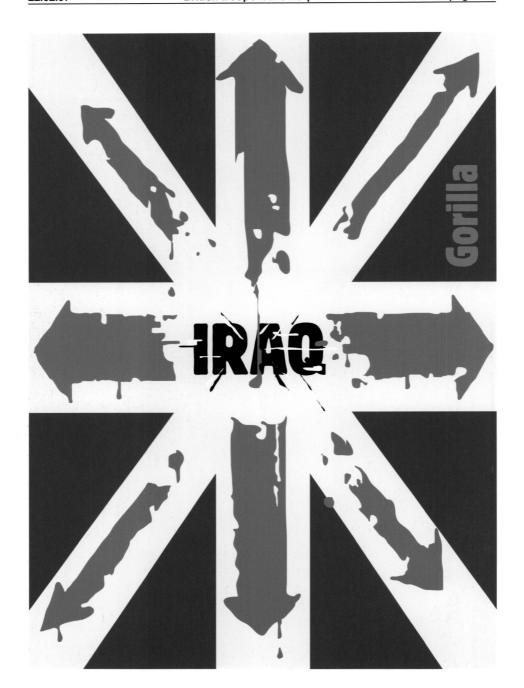

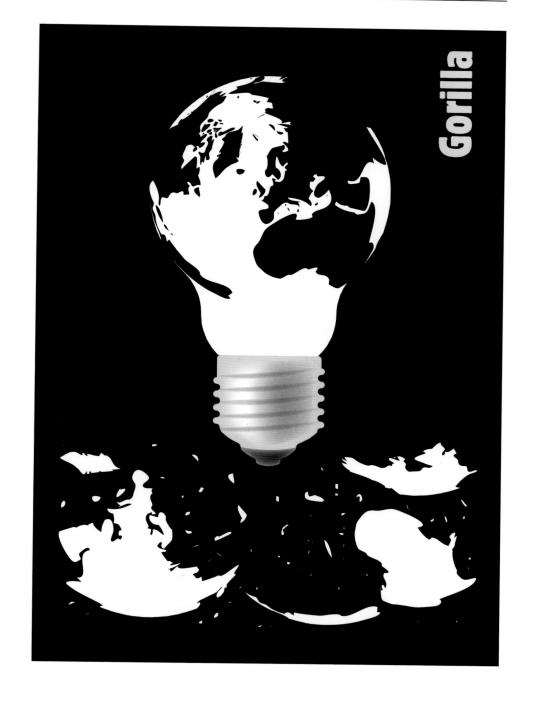

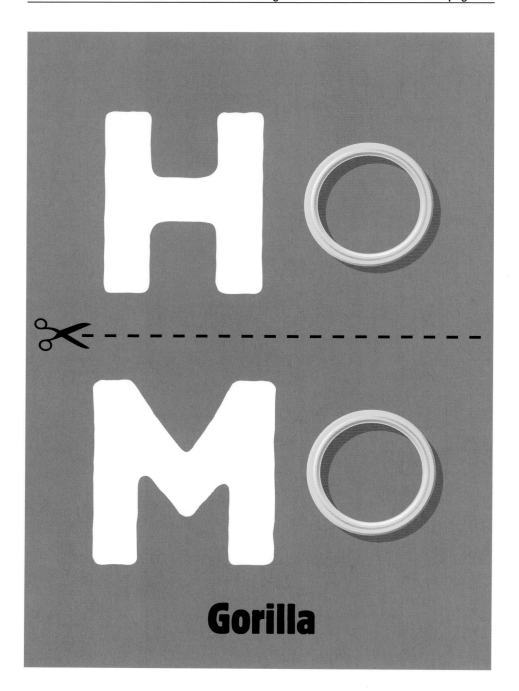

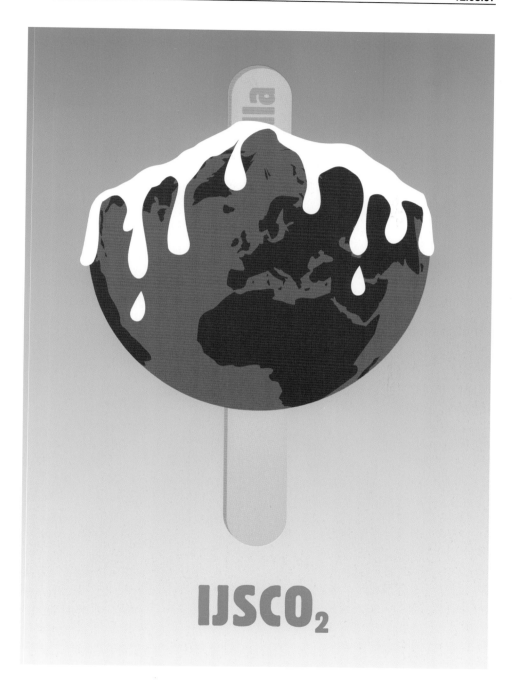

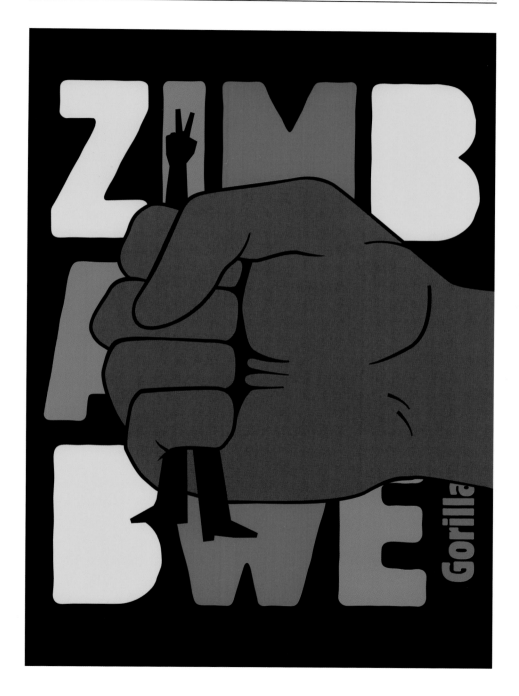

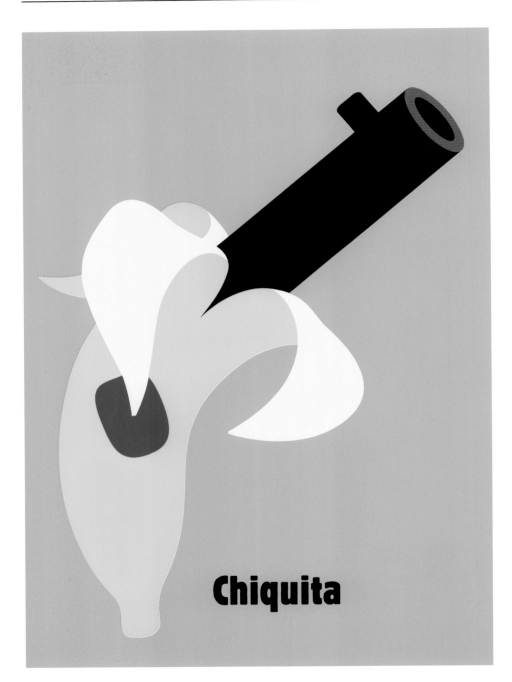

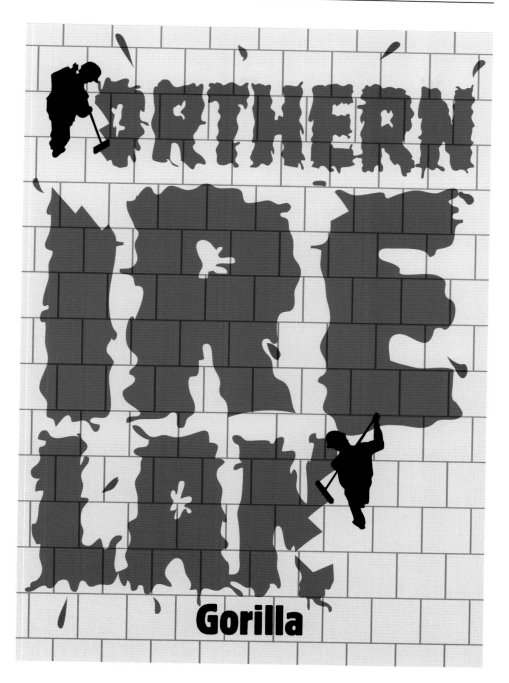

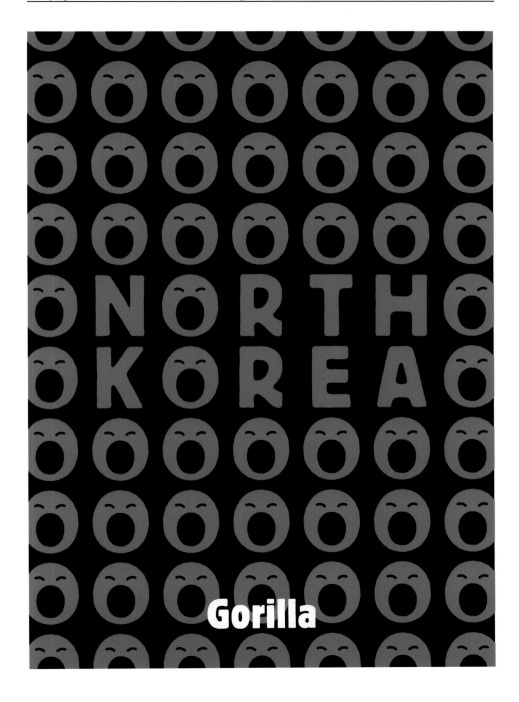

TEACHING ENGLISH
by Mahmoud Ahmadinejad

I RUN
I RAN

Gorilla he end

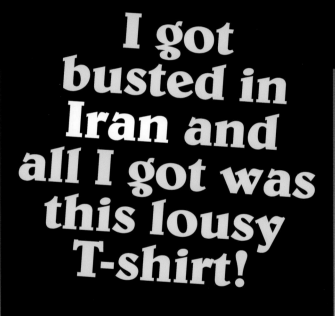

THE IRAQ AGENDA

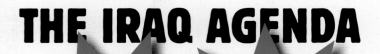

SUNDAY ATTACK DAY

MONDAY ATTACK DAY

TUESDAY ATTACK DAY

WEDNESDAY ATTACK DAY

THURSDAY ATTACK DAY

FRIDAY ATTACK DAY

SATURDAY ATTACK DAY

Gorilla

Vladimir Putin

vs.

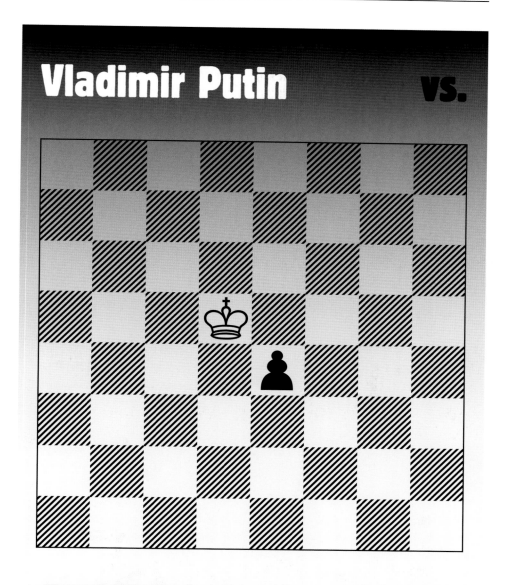

Gari Kasparov Gorilla

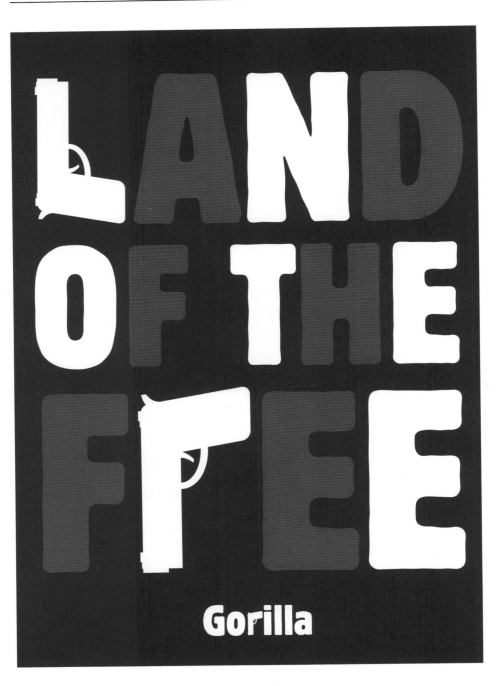

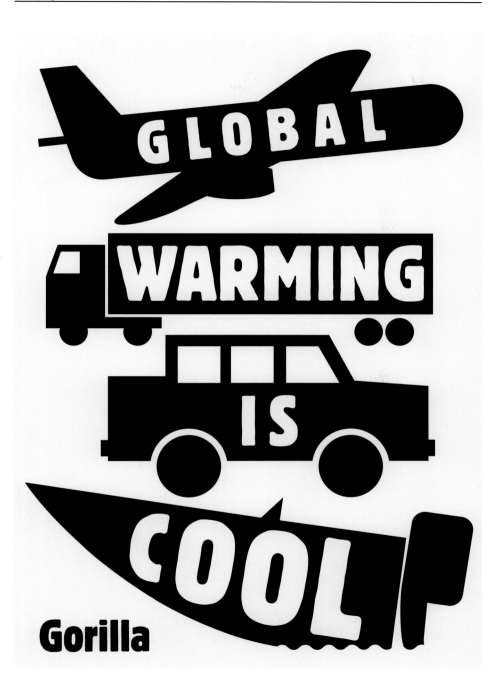

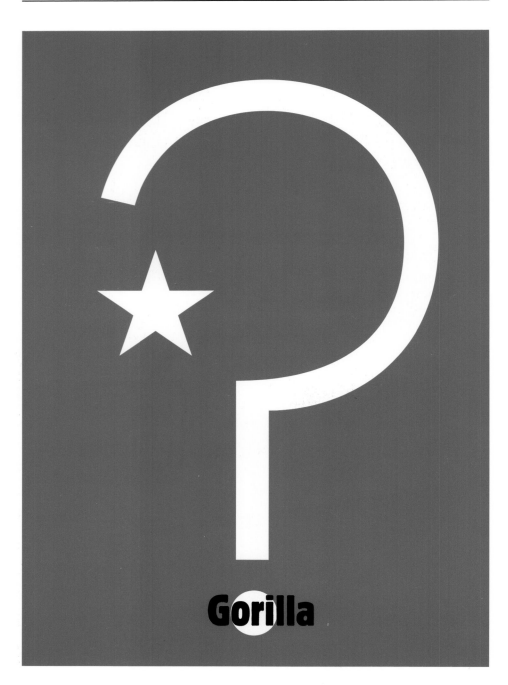

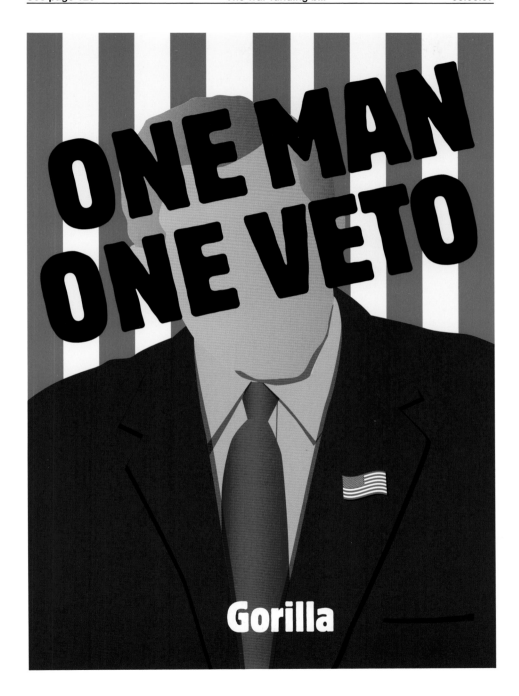

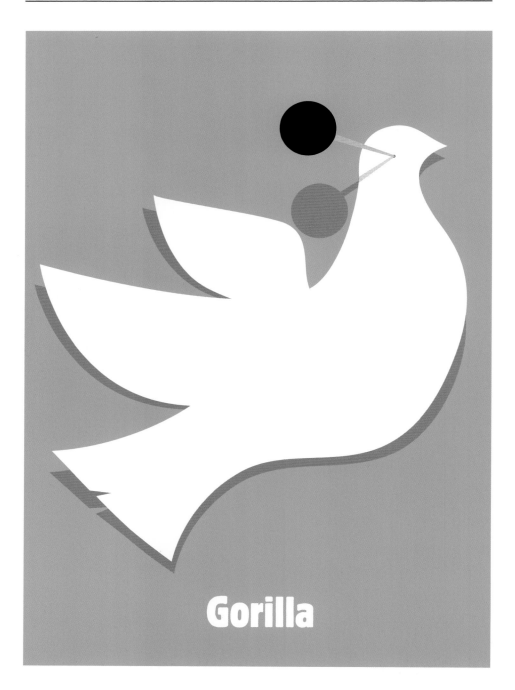

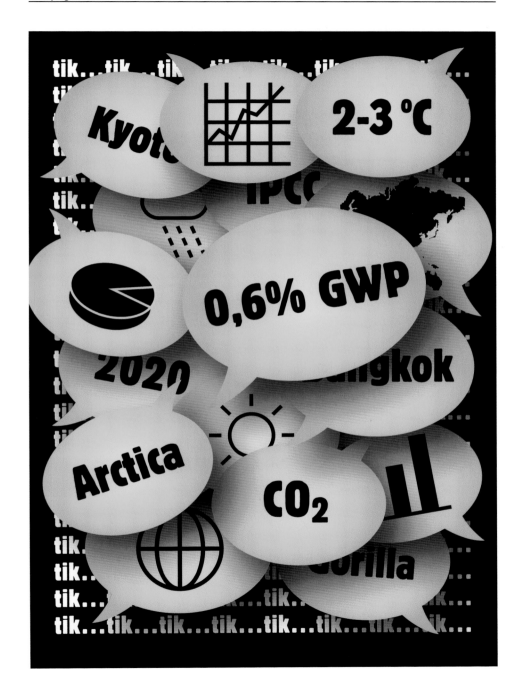

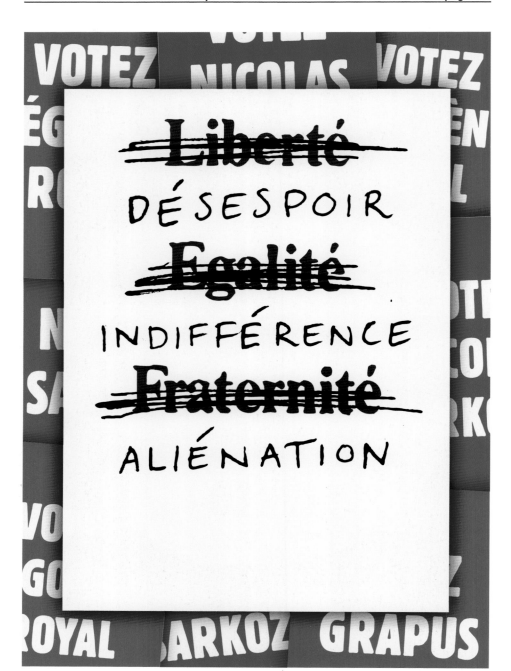

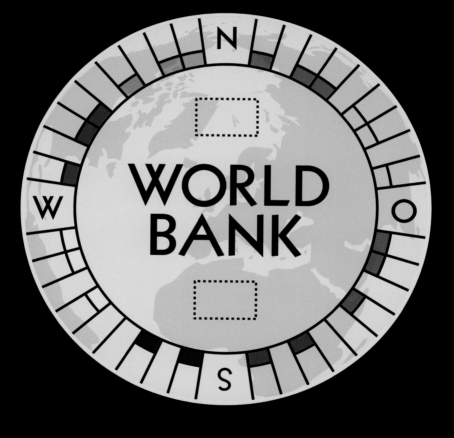

HI TURKISH ARMY! MAY WE HAVE YOUR VOTES PLEASE?

Gorilla

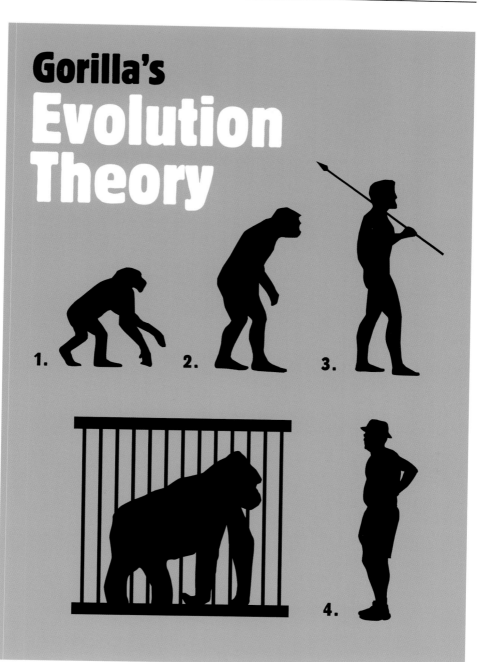

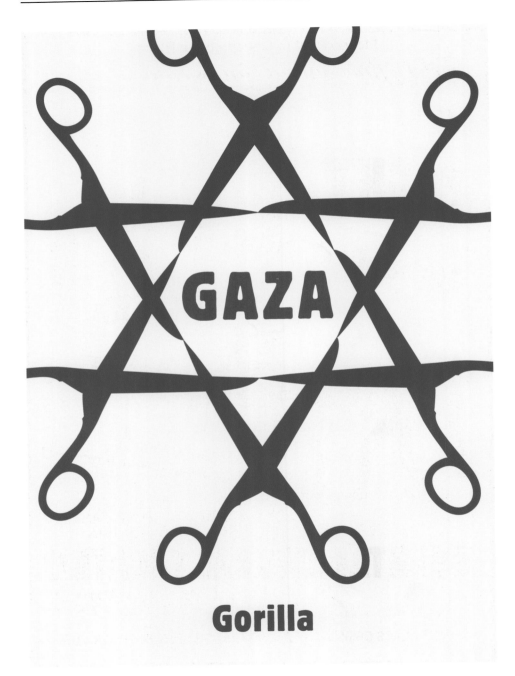

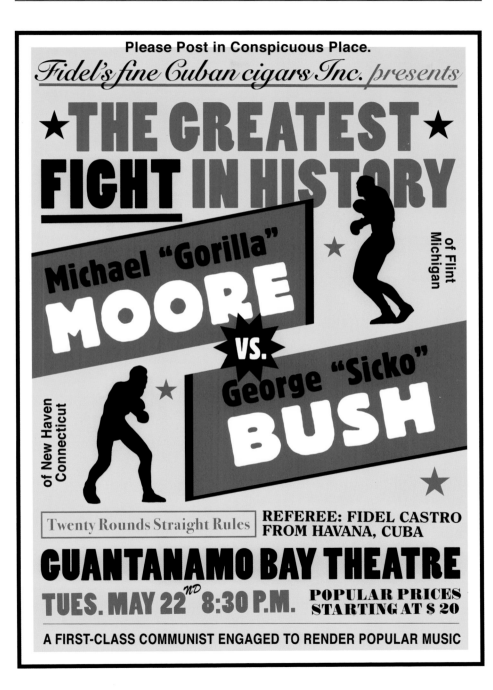

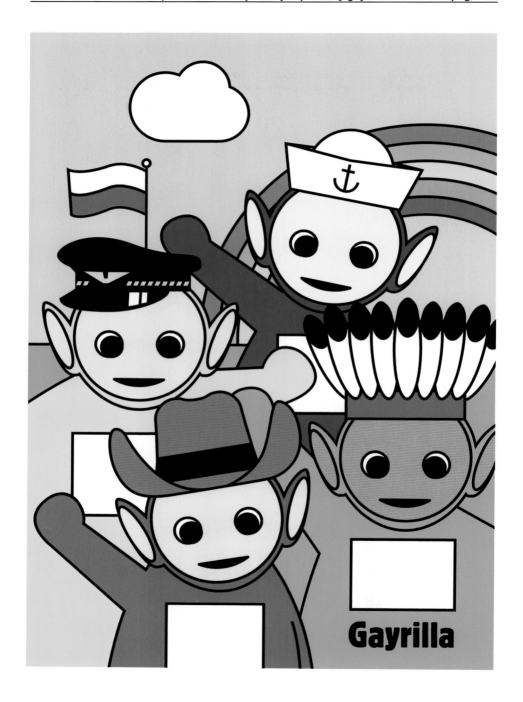

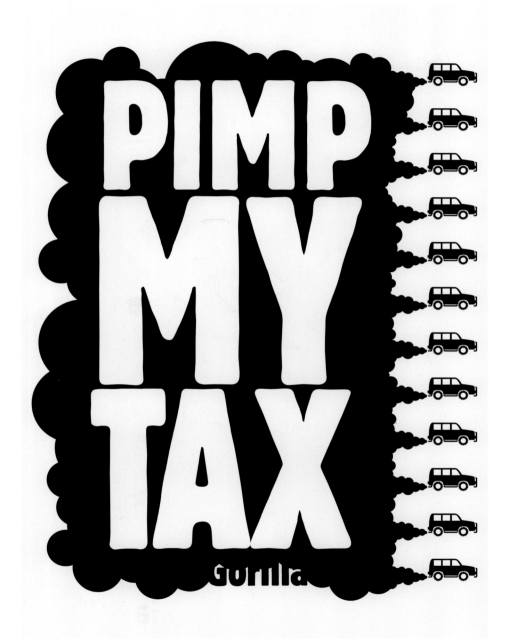

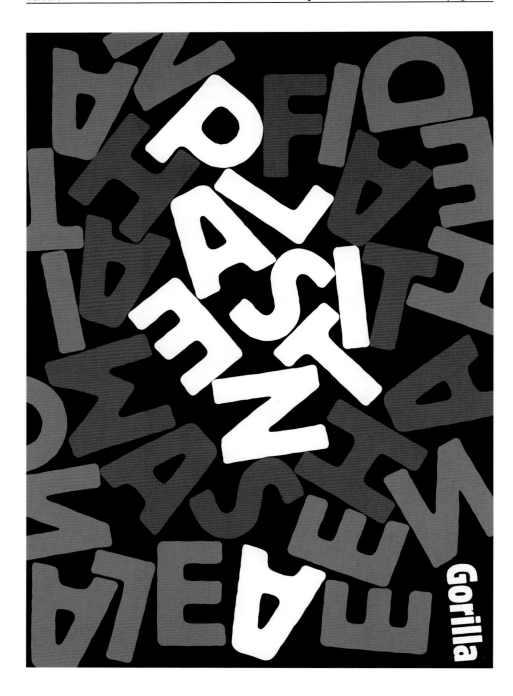

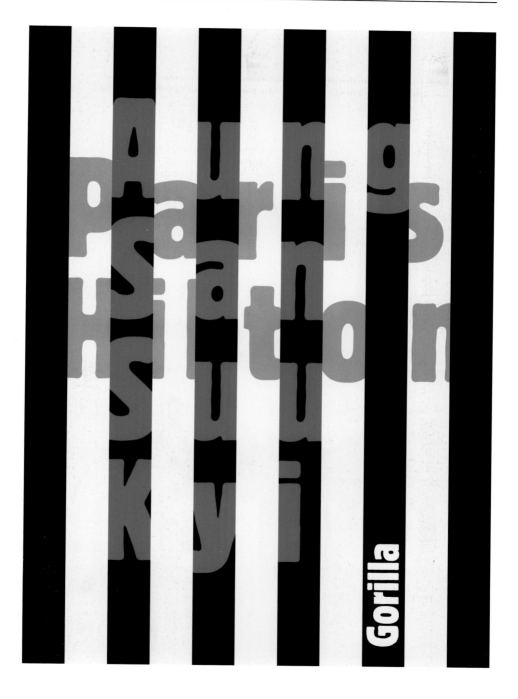

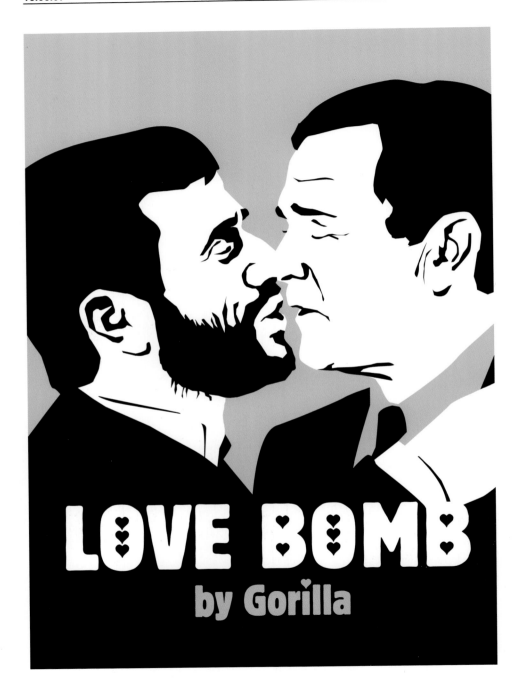

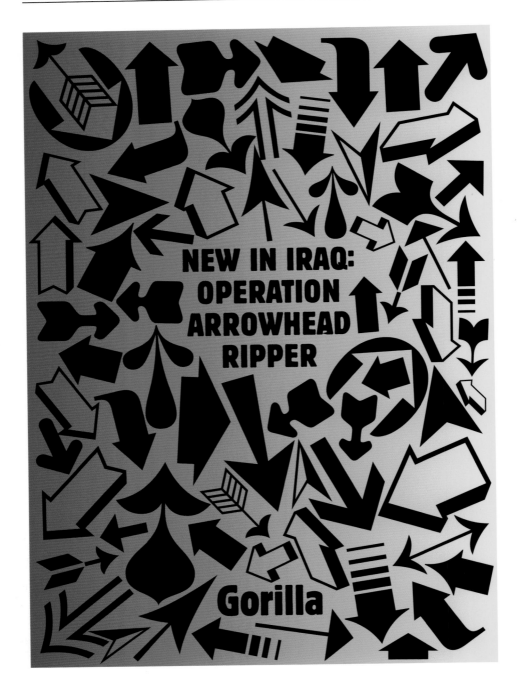

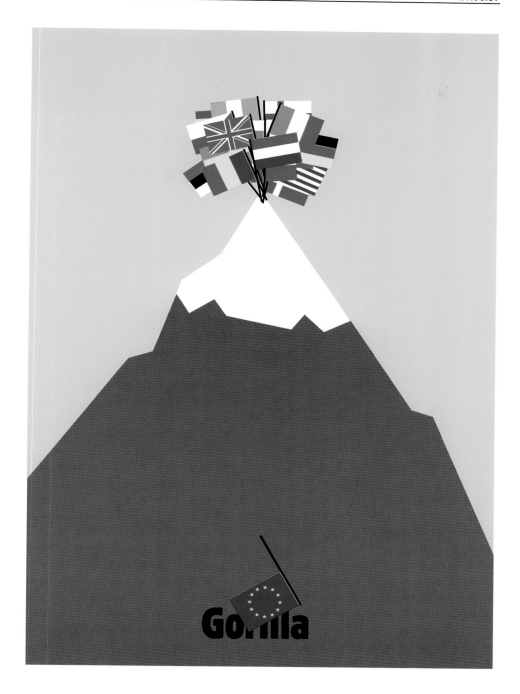

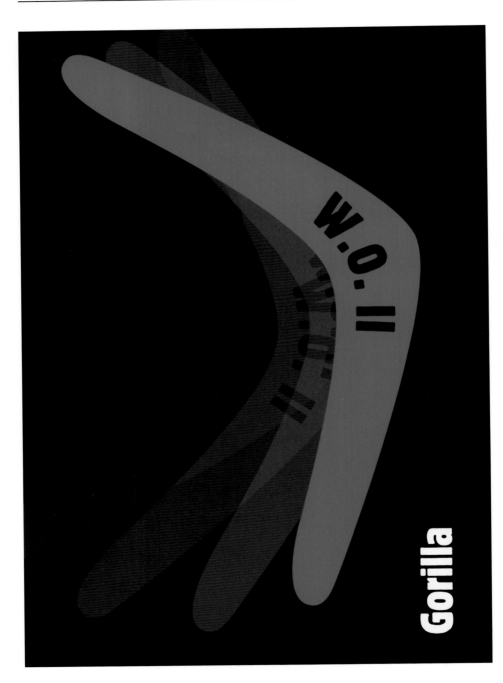

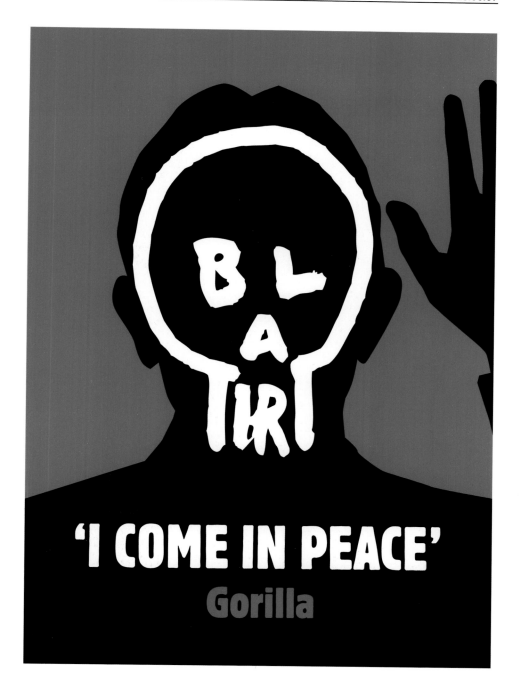

The serpent deceived me, and I ate.®

Gorilla

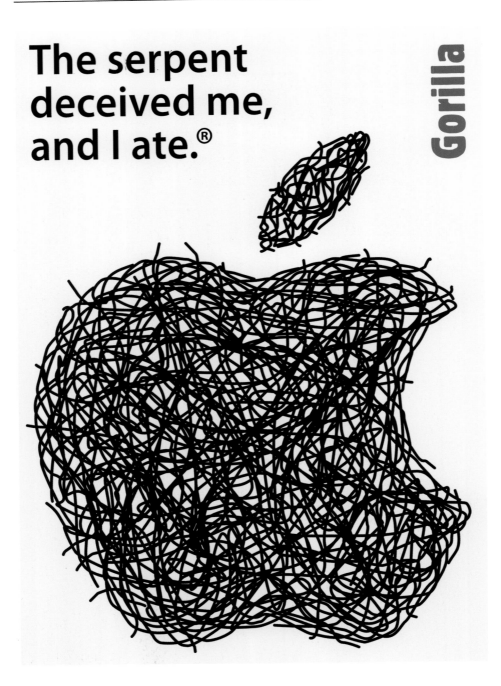

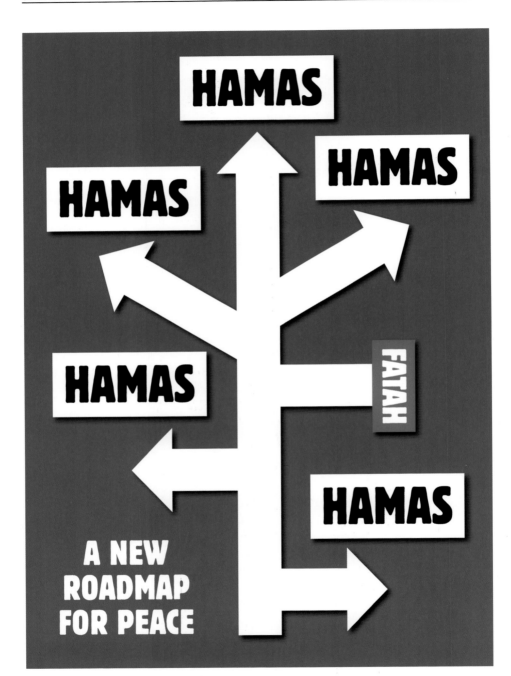

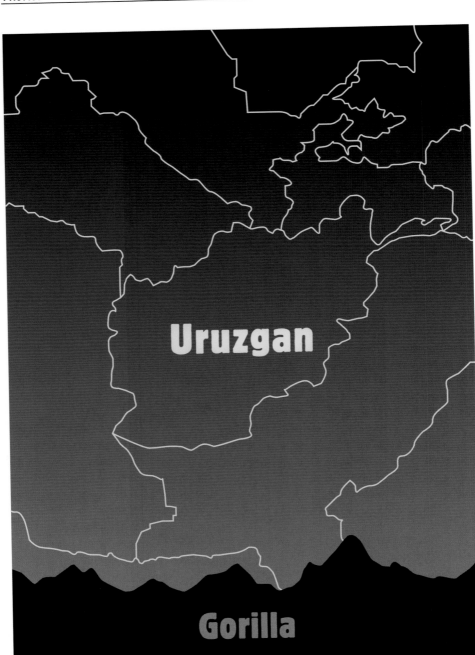

15 **P**	9 **F**	17 **Cl**	3 **Li**	8 **O**	26 **Fe**
82 **Pb**	6 **C**	1 **H**	53 **I**	11 **Na**	33 **As**
14 **Si**	92 **U**	19 **K**	35 **Br**	88 **Ra**	20 **Ca**
24 **Cr**	13 **Al**	2 **He**	15 **P**	94 **Pu**	81 **Tl**
47 **A**	30	16	56	7	50 **n**
84 **Po**	**Co**	**W**	**Au**	**O**	**Cu**

Gorilla is on holiday in the Yellow River

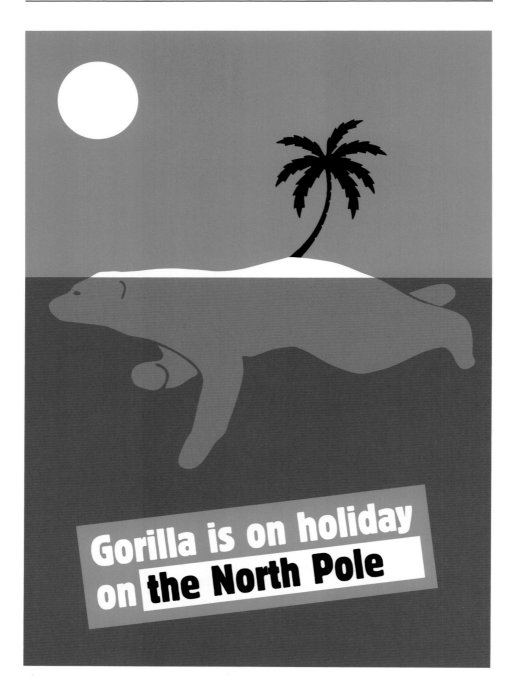

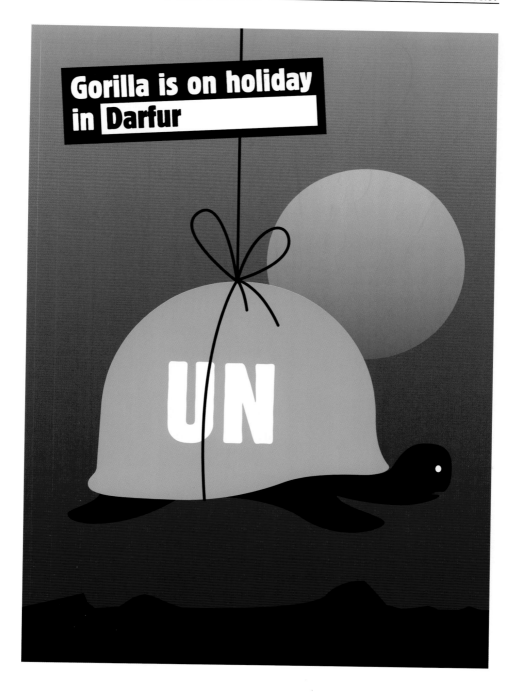

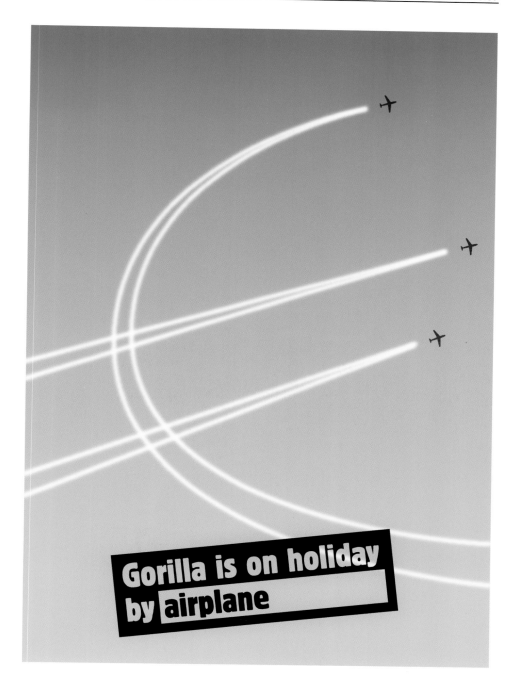

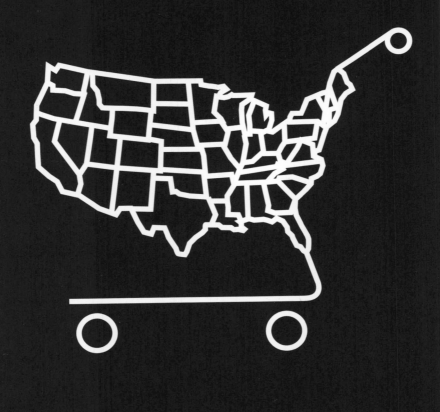

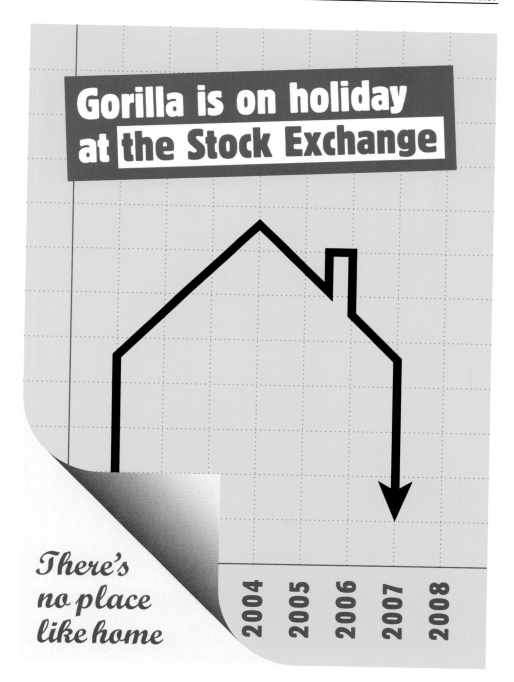

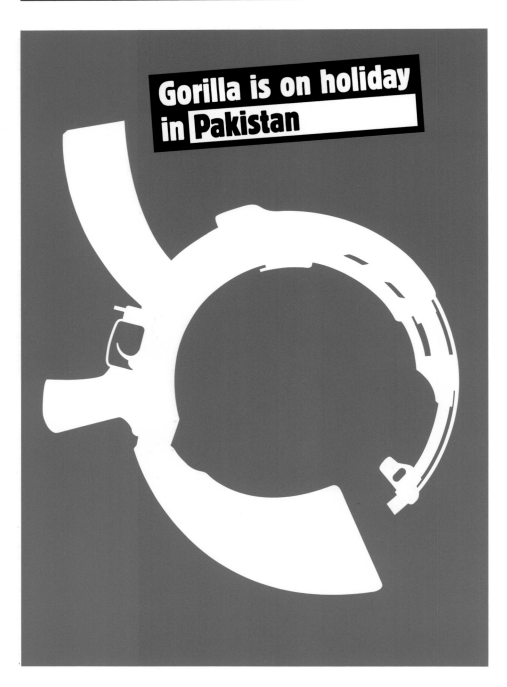

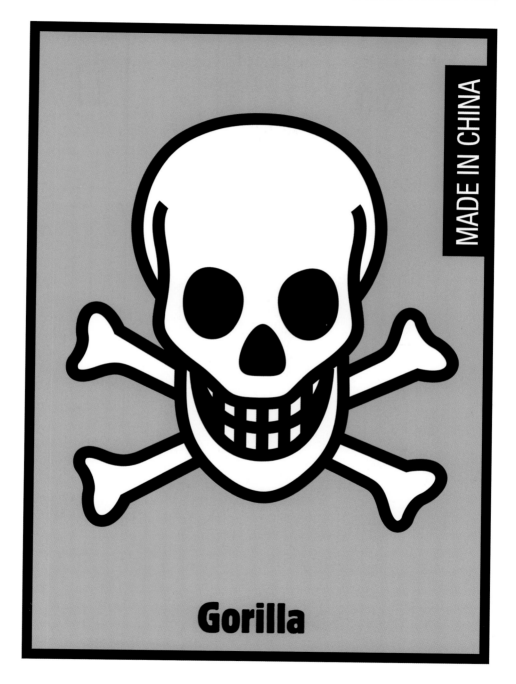

MADE IN CHINA

Gorilla

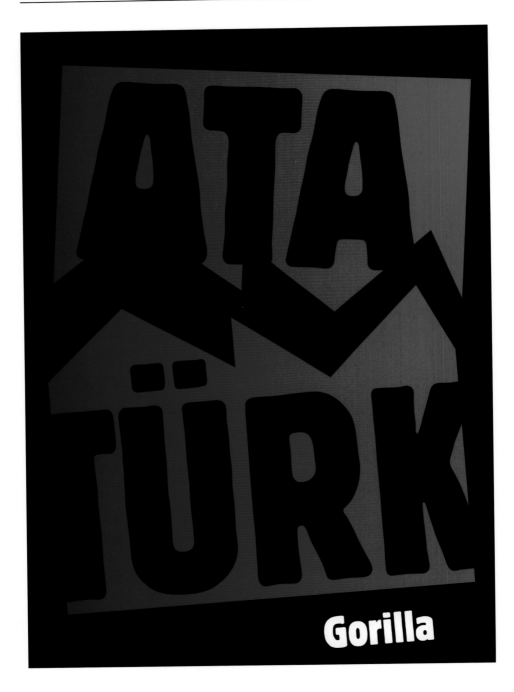

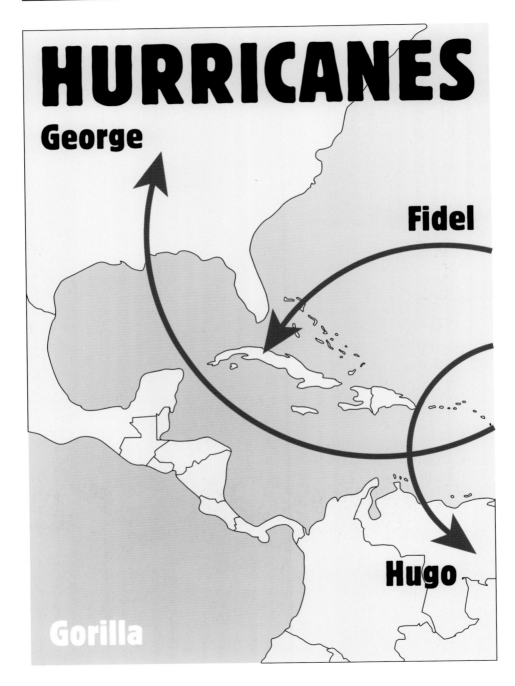

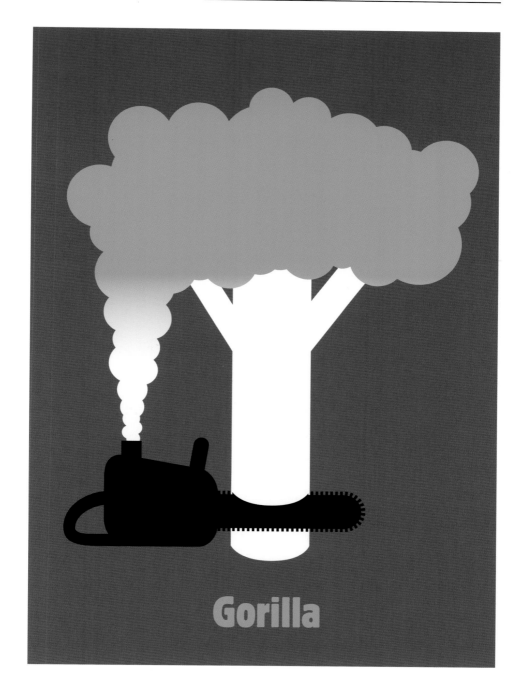

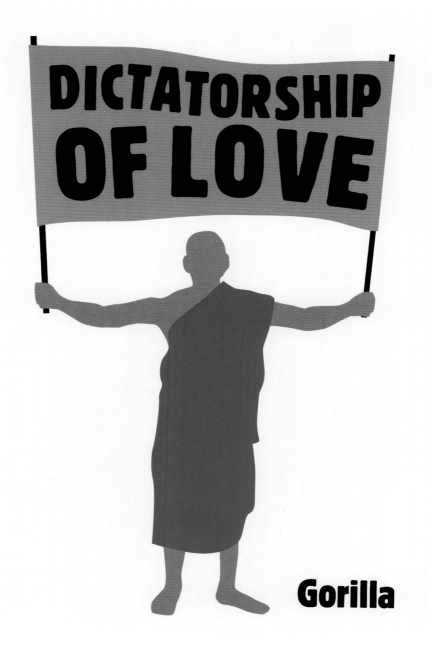

blood, oil & tears
friends forever

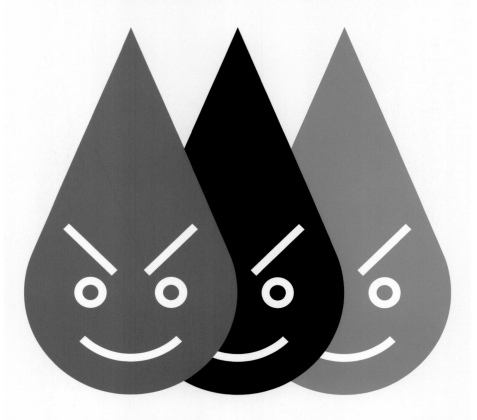

Gorilla

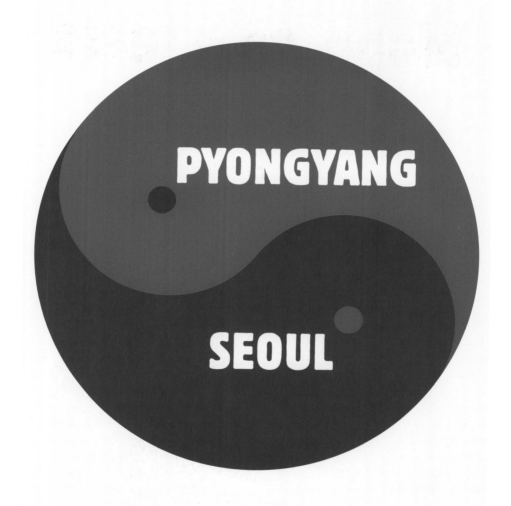

Gorilla

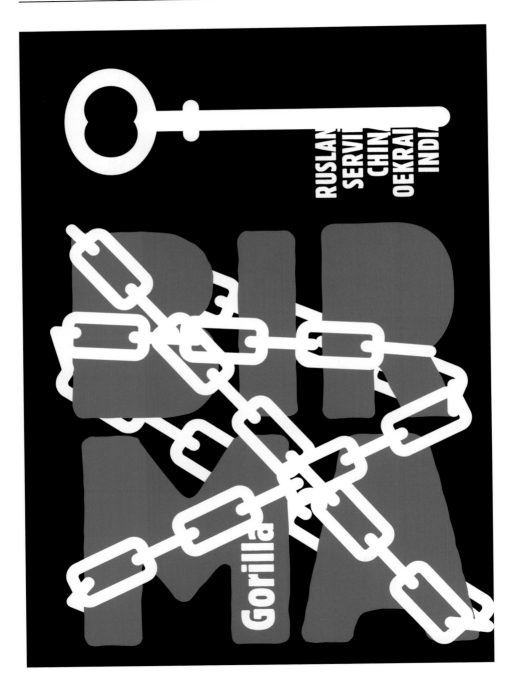

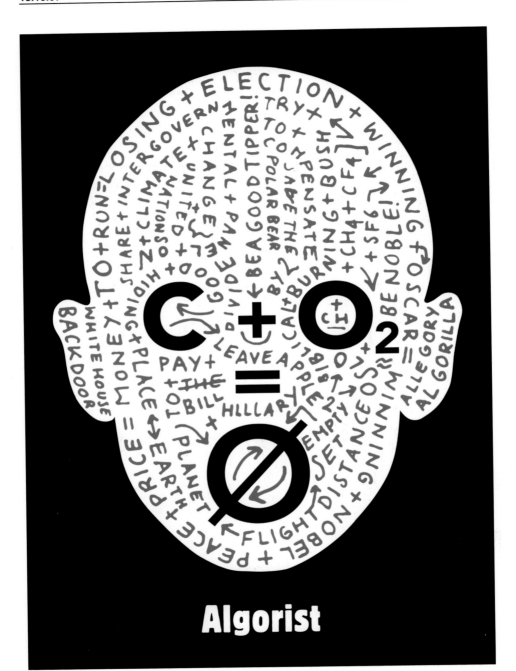

Algorist

Gorilla

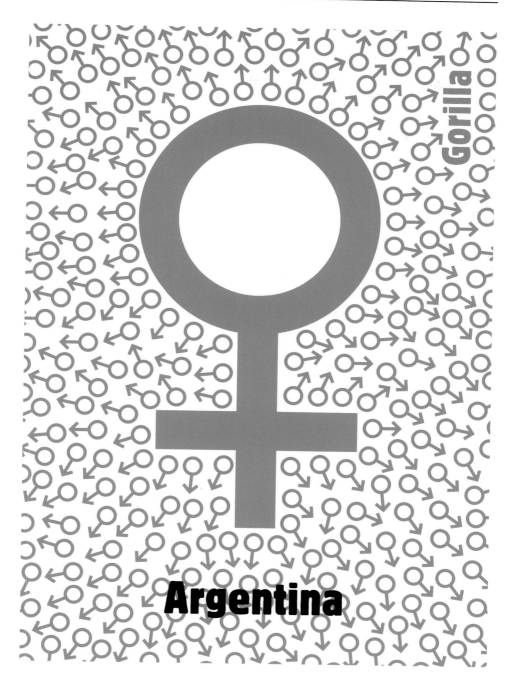

ABSOLUT IRAN

WAR ON _ERROR

Gorilla

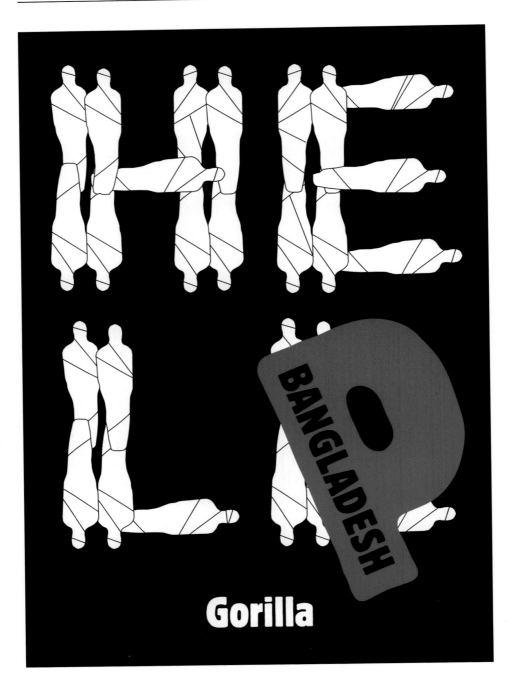

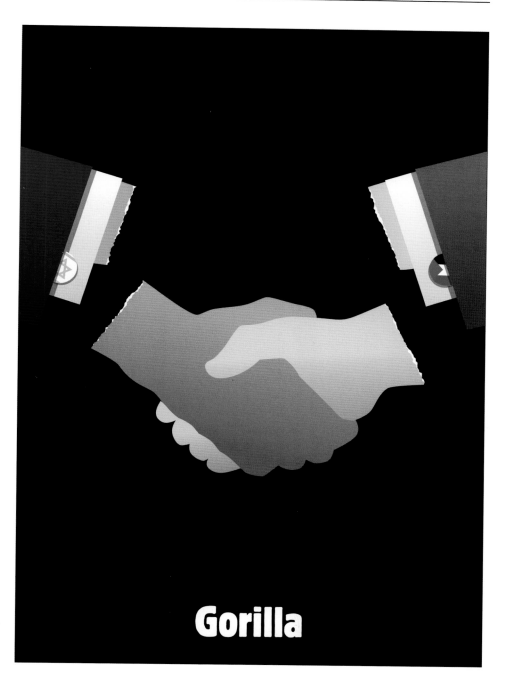

THE MASK OF POETIN

Gorilla

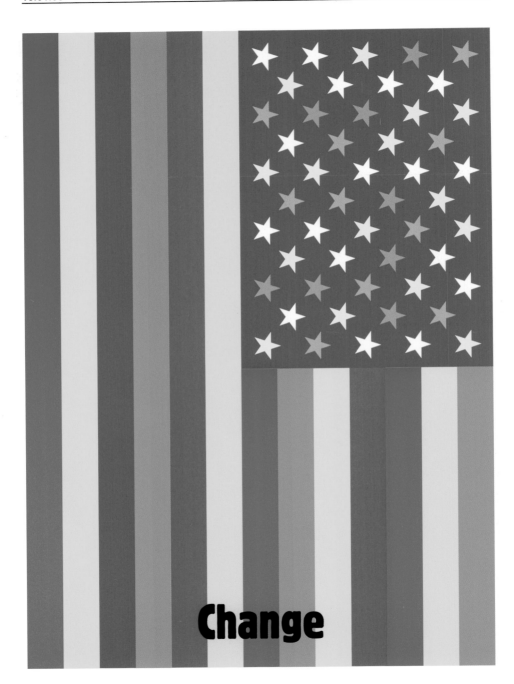

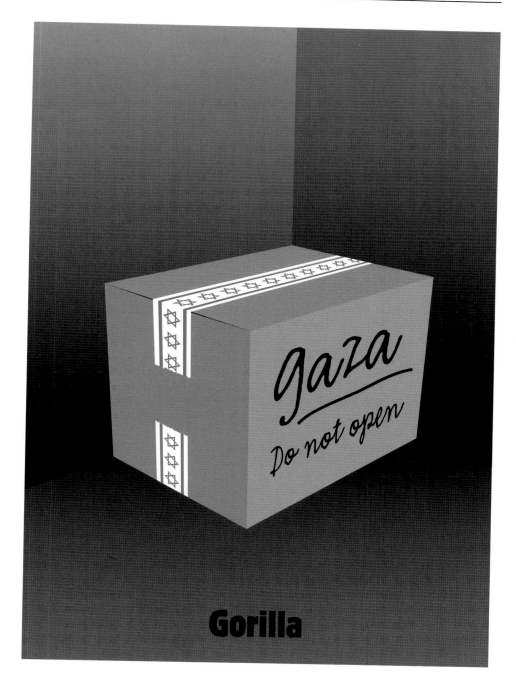

YES.WE. CAN.YES. WE.CAN. YES.WE. CAN.YES. WE.CAN. CHANGE.

Gorilla

INTERNATIONAL WOMEN'S DAY

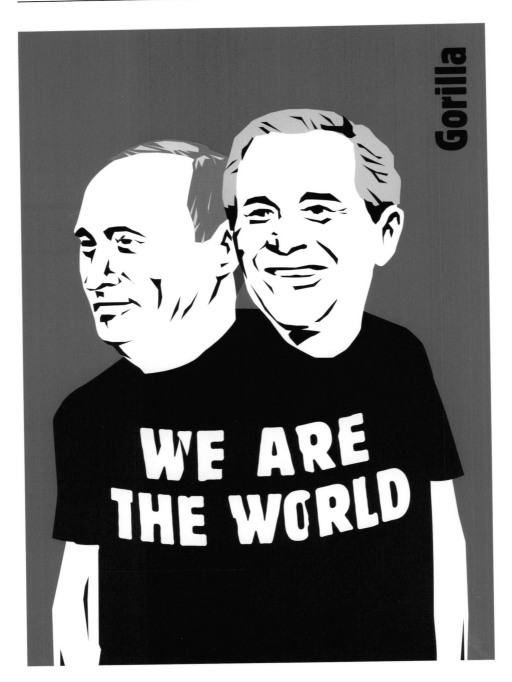

BEIJING 2008

Gorilla

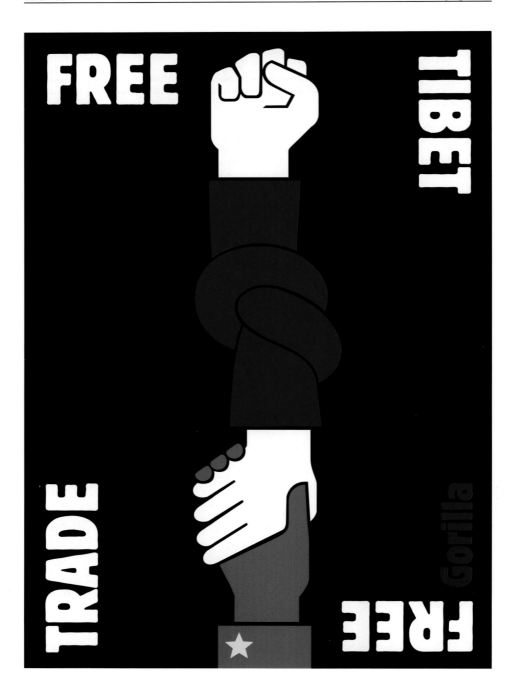

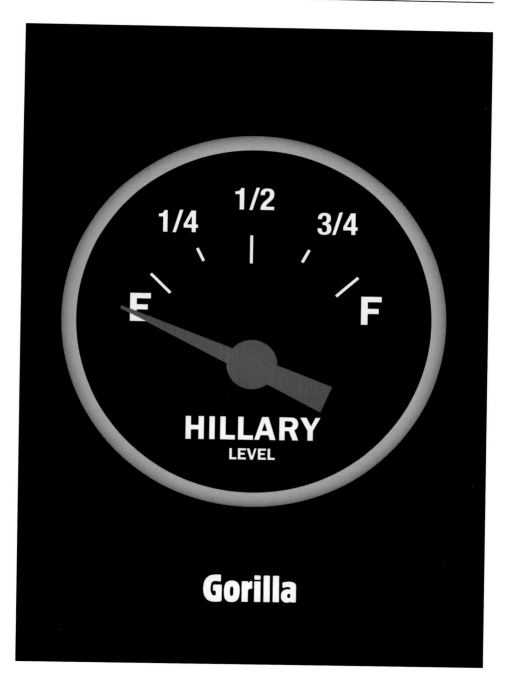

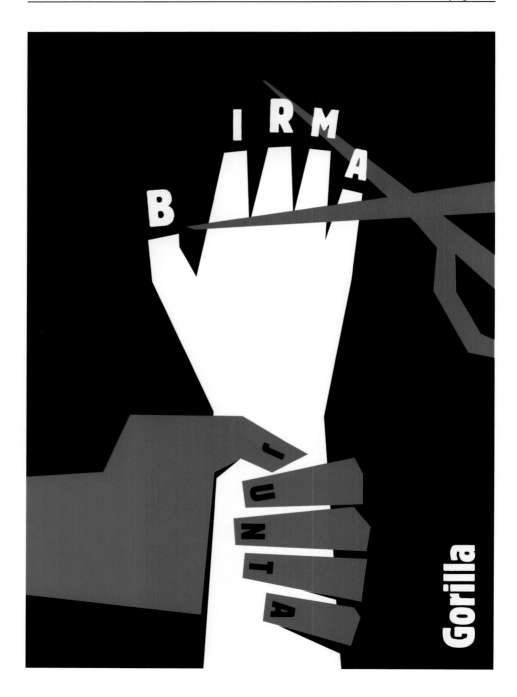

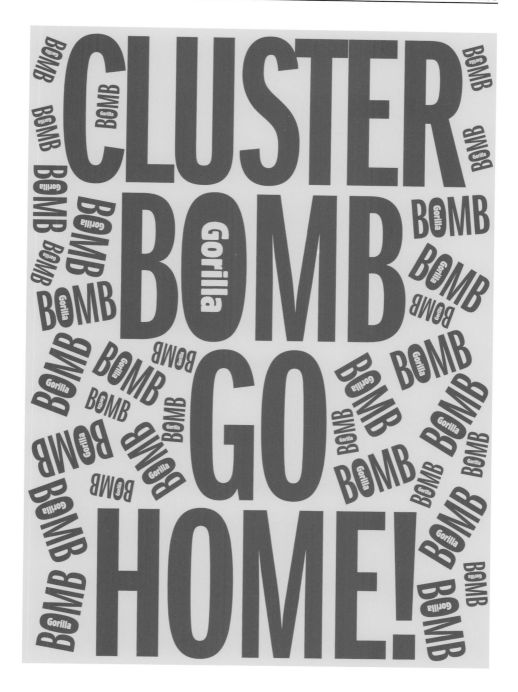

Gorilla

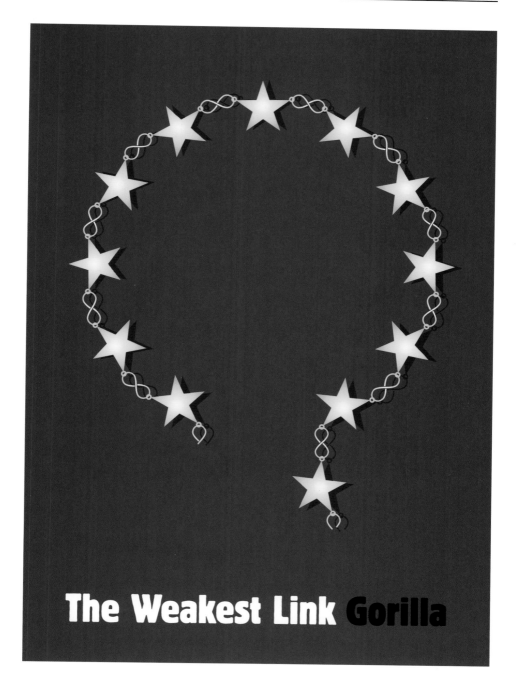

The Weakest Link Gorilla

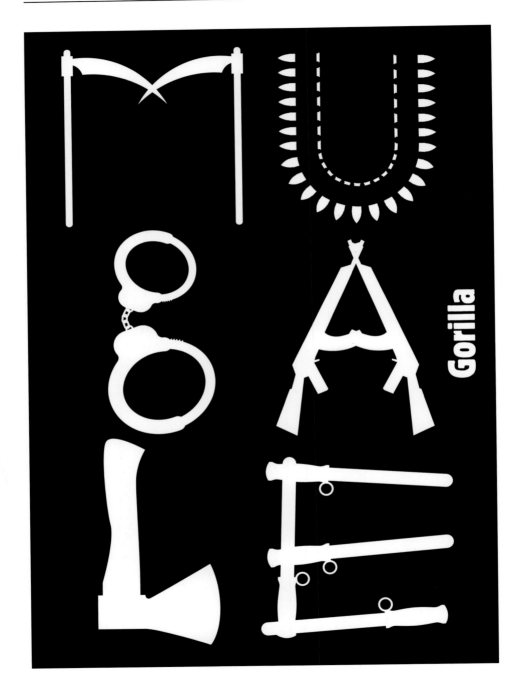

Gorilla

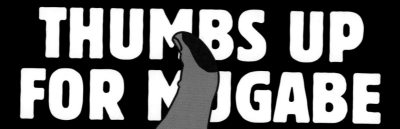

No ice on the North Pole this summer.

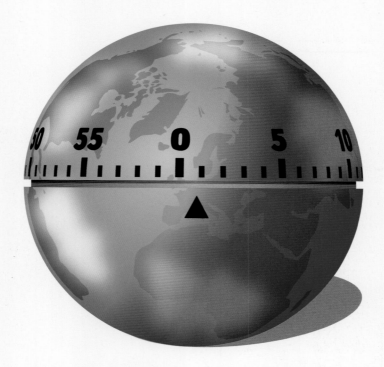

Gorilla

BORING NEWS

Since its launch in October 2006, the Gorilla project, a front-page, single-column graphic comment panel in Dutch newspaper De Volkskrant has begun to look almost heroic. The challenge of responding to the news is more usually taken on by cartoonists; Gorilla, by contrast, is graphic design.

The project is not about branding, selling or winning awards, though it does all those things, and it's not about self-expression. But the Gorilla panel is genuinely original and unquestionably design, a constant element in the daily dialogue between the newspaper and its readers.

Like a jazz group, Gorilla's designers take it in turns to make the running. The team comprises Designpolitie's Richard van der Laken and Pepijn Zurburg, Alex Clay from Lesley Moore and Herman van Bostelen. "You make a Gorilla once or twice a week," says Van der Laken. "When it is your turn there is somebody else available as your assistant / troubleshooter."

Each day's Gorilla strip begins its life the previous evening, when De Volkskrant's newsdesk sends the designers a selection of six or so news topics. "Sometimes the news is boring," says Van der Laken, "or you just don't know what to do with it. Then we take a fact that is in the news for sometime already, such as Bush, or Iraq." The tragedy of war in Iraq is an ongoing theme throughout this collection.

The "Gorilla" label is set in condensed Berthold Block, chosen for its simple "non design". The designers make play with this "masthead", which can become "Gayrilla" or "Gorille" (for the French elections). In a panel about CO2 emissions, just a few letters are visible on the wooden stick of a melting global lollipop.

But Gorilla is not all war and climate change. A clever juxtaposition of "type behind bars" contrasts socialite Paris Hilton with Burmese politician Aung San Suu Kyi. Apple gets the Gorilla treatment, as does Microsoft, Valentine's Day and evolution.

The past decade has seen much discussion about designers taking charge of content. And we have seen practitioners who bypass the client-designer model altogether, making products that engage directly with the public. In its simple mode of production and publication, Gorilla exemplifies both issues. The daily demands of De Volkskrant have made these little panels a big project: design that reaches beyond design. If the designers can sustain the level of invention and effectiveness shown here, they will do our culture, and design, a great service.

John L. Walters, editor, Eye, eyemagazine.com

UNITED STATES OF AMERICA BY

Gorilla

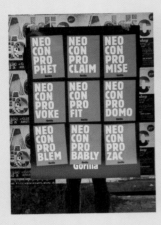

The neocon agenda of George Bush/ 10.01.2007

Neoconservatism is rife in the US. One of the things they promote is the US's current hegemony in the world.

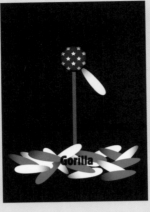

Heavy criticism by U.S. allies/ 04.09.07

International support for US foreign policy further eroded.

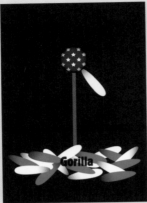

Hurricane season/ 05.09.07

America prepares itself for the hurricane season.

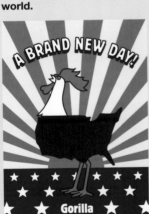

Bush era nears its end/ 09.11.06

Democrats achieve majority in Senate elections.

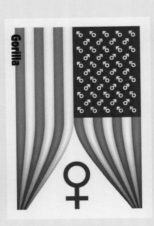

Hillary Clinton/ 22.01.07

On 20 January 2007, almost a week after Barack Obama, Hilary Clinton announces that she is standing as candidate for American president.

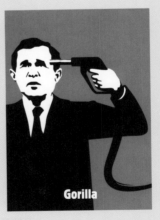

State of the Union: "we are addicted to oil"/ 25.01.07

The president states in his State of the Union Address that oil consumption in the US will have to be reduced by 20% in the next 10 years.

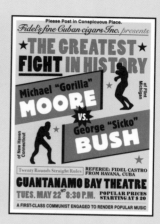

The war funding bill/ 03.05.07

President Bush keeps his vow to veto the war funding bill. The president says that the pullout deadline is a 'date for failure'.

Shooting at Virginia technical university/ 17.04.07

A student of a Virginia university kills 32 people and himself.

Michael Moore vs. George Bush/ 22.05.07

Michael Moore's film 'Sicko' states that healthcare is much better organised in Cuba than in America.

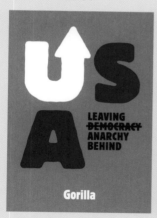

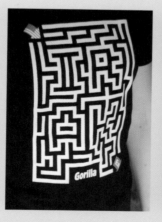

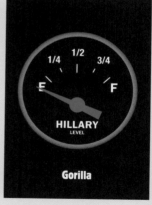

US withdrawal out of parts of Iraq/ 07.12.06

Iraq committee wants to withdraw American forces.

U.S. exit strategy iraq/ 27.10.06

President Bush increasingly comes under fire in his own country over the war in Iraq.

Hillary's Clinton's cashbox is empty/ 08.05.08

After Hillary Clinton's call for a petrol tax holiday it is clear that the cashbox is empty, the mood desperate.

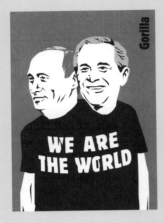

Bush/Putin era is almost over/ 05.04.08

Meeting between two departing world leaders.

YES.WE.
CAN.YES.
WE.CAN.
YES.WE.
CAN.YES.
WE.CAN.
CHANGE.

Gorilla

Obama:/ 12.02.08

Barack Obama overtakes Hillary Clinton after Super Tuesday.

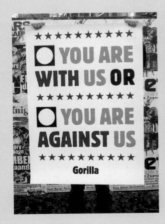

Congressional elections/ 08.11.06

During the Congressional elections in the US the Republicans traditionally exploited the fundamental fear that prevails among average Americans.

American pre-elections/ 10.01.08

Hillary Clinton and Barack Obama fight it out over change in the US.

WAR ON TERROR BY

Gorilla

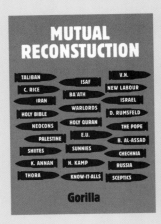

Global warning/ 21.10.06

The Netherlands decides to reinforce its troops in Afghanistan. The motto 'Reconstruction' is far away.

The latest Bin Laden video/ 11.09.07

Six years after the attacks on the Twin Towers and the Pentagon, Osama Bin Laden has still not been captured.

Clumsy attempt at terrorism in UK/ 03.07.07

A group of British Muslim extremists who were planning a series of attacks are arrested.

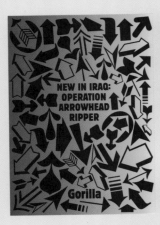

U.S. launch new operation in Iraq/ 20.06.07

The US launches yet another offensive against insurgents in Iraq.

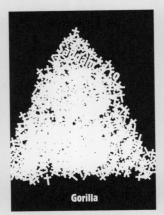

Saddam & Co executed/ 04.01.07

After Saddam Husseim's execution his henchmen are also sentenced to death. After all the innocent and senseless deaths that have already occurred.

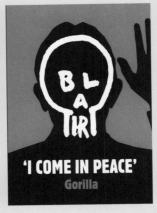

Resignation of Tony Blair/ 28.06.07

Departing prime minister Tony Blair is appointed Middle East peace envoy.

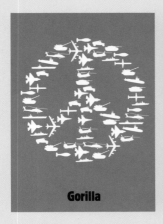

NATO summit/ 24.10.07

A NATO summit is held in Noordwijk, The Netherlands.

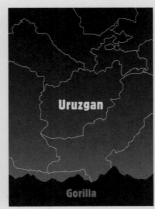

Dutch soldiers should stay in Uruzgan/ 11.07.07

The Dutch mission in the Afghan province of Uruzgan turns out to be highly dangerous.

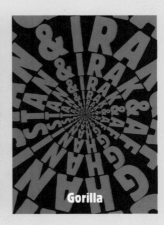

Afghanistan & Iraq/ 19.06.07

The wars in Afghanistan and Iraq dominate the news.

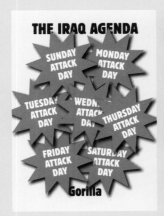

The Iraq agenda/ 13.04.07

After yet another bomb attack in Iraq, this time killing three members of parliament, it seemed as though every day was a bull's-eye.

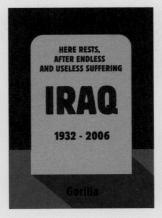

Does Iraq still exist?/ 30.10.06

After America's highly debatable invasion of Iraq, the country was in danger of disintegrating into three parts in conflict with one another.

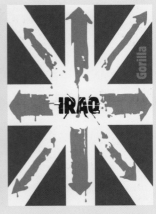

British troops leave Iraq/ 22.02.07

After increasing public pressure, British troops start to withdraw from Iraq.

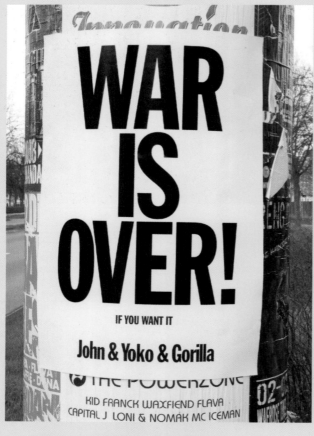

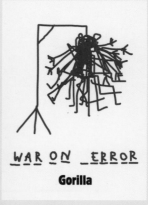

Japan no longer partici-
pates in the "war on terror"/
02.11.07

**Japan decides to no longer
participate in the 'war on
terror'.**

John Lennon † 08.12.80/
08.12.06

**Homage to the famous
poster by John Lennon
and Yoko Ono to mark
the anniversary of John
Lennon's death.**

THE MIDDLE EAST BY

Gorilla

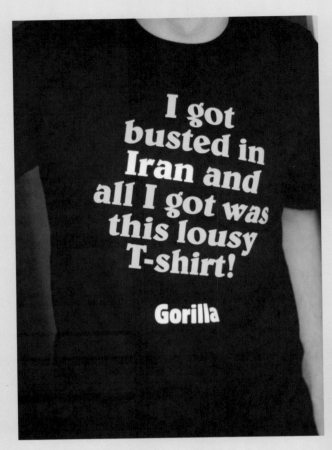

British soldiers arrested at sea by Iran/ 05.04.07

After a crazy cat-and-mouse-game between Great Britain and Iran, Iran frees captured British marines and sailors.

Unrest after Israel starts digging at temple mountain/ 10.02.07

Riots erupt on the Temple Mount after excavations by Israel in the vicinity of the Al-Aqsa mosque.

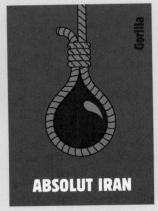

Death sentence/ 30.10.07

Great concern about death sentence imposed on human rights activist in Iran. Sources say that people are being executed in Iran every day.

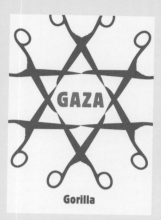

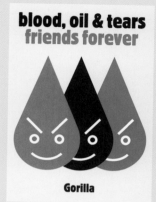

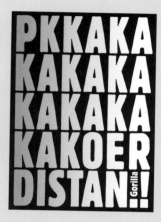

Closed of by Israel/ 21.05.07

Israel carries out air raids on the Gaza Strip in an attempt to eliminate Hamas members.

Friends forever/ 29.09.07

Behind a lot of armed conflict lies a battle for natural resources, particularly oil.

PKK takes pot-shots/ 23.10.07

Turkey launches a military campaign in Northern Iraq after repeated attacks by the PKK on Turkish soldiers.

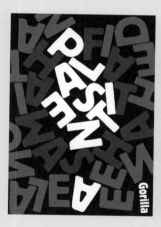

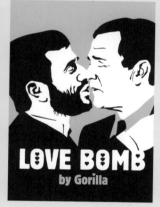

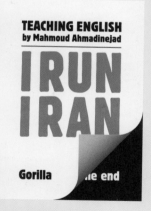

Unstable Palestinian unity/ 13.06.07

National unity is Palestine is further away than ever, now that Hamas and Fatah are fighting each other.

U.S. develop new weapon: Love Bomb/ 16.06.07

The US military investigated building a "gay bomb", which would make enemy soldiers "sexually irresistible" to each other, government papers say.

Teaching English by Mahmoud Ahmadinejad/ 02.04.07

Row between Iran and England after a number of English soldiers were seized in the Gulf. They were freed a week later.

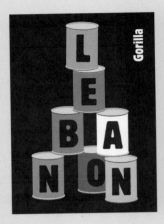

**Unstable peace in
Lebanon/ 26.01.07**

Lebanon is unstable after
heavy destruction wrought
by the Israeli army in their at-
tempt to eliminate Hezbollah.

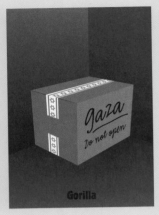

**Israel closes the border
with Gaza again/ 24.01.08**

Israel seals Gaza off from
the outside world.

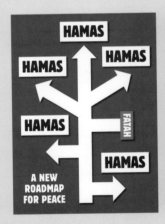

**The West can no longer
ignore Hamas/ 06.07.07**

After the release of Alan
Johnston the West can no
longer ignore Hamas.

**Peace talks are nothing
more than a photo
opportunity/ 28.11.07**

In the American city of
Annapolis, Israel and the
Palestinian Authority decide
to press on with peace
negotiations.

EUROPE AND THE REST OF THE WORLD BY

Gorilla

"Tinky Winky is possibly gay"/ 30.05.07

In a series of anti-gay incidents, the Polish government suspects Tinky Winky of being gay.

WW II/ 22.06.07

WW II returns to Europe via Poland during an EU summit.

Expansion of EU/ 03.01.07

Many EU member states distrust the accession of Bulgaria and Rumania to the Union.

Belgian police arrests corrupt EU employes/ 28.03.07

Police conduct raids on various EU officials suspected of corruption.

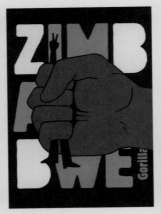

Zimbabwe/ 19.03.07

Dictator Robert Mugabe clamps down on opposition.

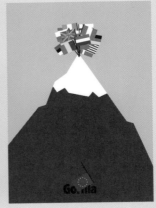

Euro summit/ 21.06.07

At the European summit most countries are preaching to the converted and unity is far away.

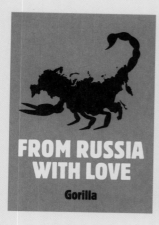

Former KGB agent found poisoned/ 25.11.06

Kremlin possibly involved in murder of ex-spy Aleksandr Litvinenko.

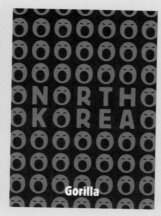

Hunger in North Korea/ 29.03.07

Serious food shortages in North Korea because of poor harvests.

Japanese "comfort girls" during WW II/ 17.03.07

Japan refuses to acknowledge the existence of sex slaves, known as comfort girls, used by the Japanese army during WW II.

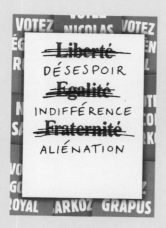

French presidential elections/ 07.05.07

Sarkozy wins the French presidential election. There are fears of riots in the banlieues.

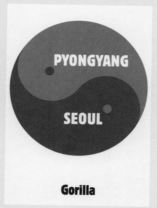

Korea: Yin Yang/ 03.10.07

North and South Korea.

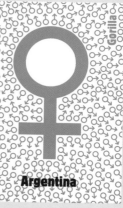

Argentinean elections/ 29.10.07

Cristina Fernández de Kirchner becomes the first elected female president of Argentina. She succeeds her husband.

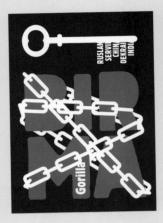

Burma/ 05.10.07

Russia, Serbia, China, Ukraine and India keep military junta in power by supplying arms.

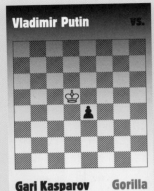

Putin vs. Kasparov/ 16.04.07

Former world chess champion Gary Kasparov leads the Russian opposition against president Putin.

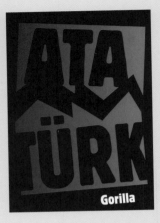

Muslim party wins Turkish elections/ 30.08.07

Islamist Gül appointed head of state in secular Turkey.

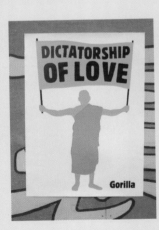

Myanmar monks protest peacefully/ 25.09.07

Burma's military junta cracks down on peaceful protests by Buddhist monks.

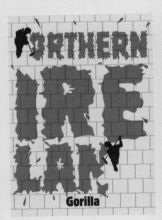

Protestants and Catholics share power in N.I./ 27.03.07

Former arch-enemies from Protestant and Catholic sides form a government of national unity.

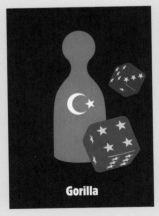

Uncertain relationships of Turkey and EU/ 30.11.06

Deadlock between army and Islamists over presidential candidate Gül.

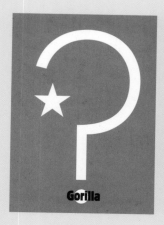

Turkey and EU/ 02.05.07

EU uses Turkey's possible membership as a means of pressure concerning Cyprus.

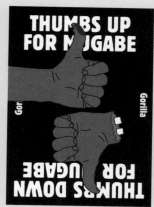

Election day in Zimbabwe/ 27.06.08

Thugs can tell from ink on the thumb whether or not people have voted in the Zimbabwe election.

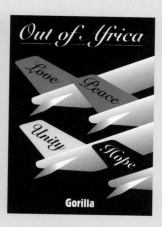

Tribal clashes in Kenya/ 04.01.08

Serious riots break out in relatively peaceful Kenya after presidential election.

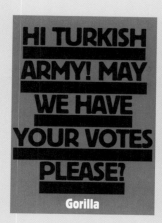

Hi Turkish army!/ 14.05.07

Mass protests against the influence of Islam on Turkish politics on the same day as the Eurovision Song Contest.

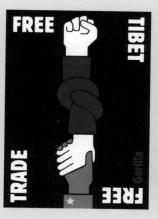

Free Trade Free Tibet/ 12.04.08

Dutch provincial and municipal administrators travel en masse to China.

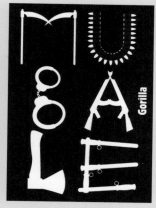

Mugabe hits opposition with violence/ 25.06.08

According to the international community, Mugabe is no longer the legitimate leader of Zimbabwe. He is using brute force and intimidation to wrest an election victory.

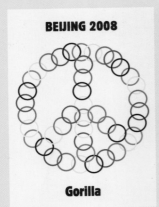

Olympic Peace/ 08.04.08

IOC wants 'peaceful solution' in Tibet.

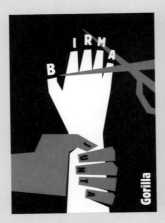

Birma Junta/ 27.05.08

Aid organisations barred from Burma

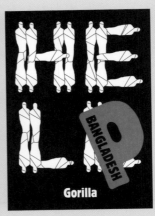

Floods in Bangladesh/ 21.11.07

Bangladesh in shock after hurricane.

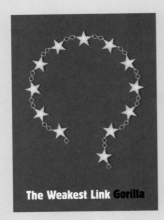

Ireland says 'no' to E.U. treaty/ 16.06.08

makes it clear that the EU is only as strong as its weakest link.

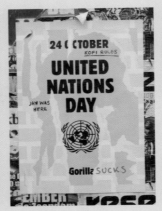

United Nations Day/ 24.10.06

The Charter of the United Nations came into force on 24 October 1945. In connection with this, 24 October is United Nations Day.

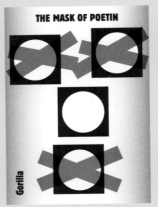

Presidential elections in Russia/ 07.12.08

As expected, Vladimir Putin's party United Russia is the big winner of the parliamentary elections on 2 December 2007. The elections are believed not to have been fair.

ON HOLIDAY WITH

Gorilla

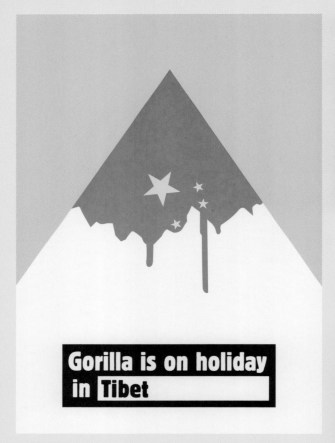

Gorilla is on holiday in Tibet

Tibet/ 14.08.07

Tibetan culture rapidly disappearing because of Chinese influence since the invasion of 1950.

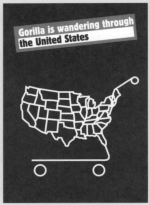

Gorilla is wandering through the United States

United States/ 10.08.07

After years of living beyond its means, the United States struggles with major credit shortage and a crisis in the housing market.

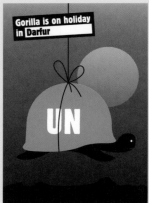

Gorilla is on holiday in Darfur

Peace mission Darfur/ 02.08.07

After months of looking on, the UN decides to send a peace mission to Darfur.

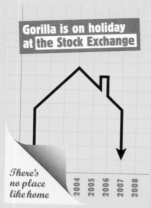

Gorilla is on holiday at the Stock Exchange

There's no place like home

2004 2005 2006 2007 2008

Monetary crisis/ 13.08.07

Bankruptcy of several American mortgage lenders portends monetary crisis.

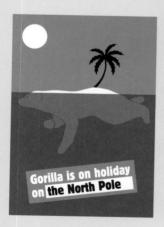

Gorilla is on holiday on the North Pole

North Pole/ 31.07.07

In case you hadn't noticed, global warming is changing the climate and melting the poles.

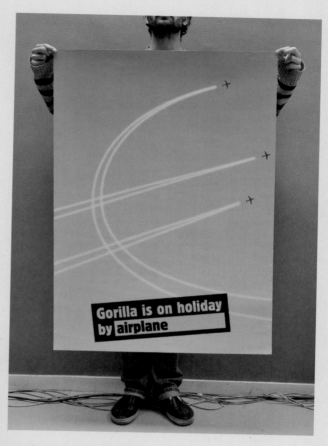

Gorilla is on holiday by airplane

ECOTAX on cheap tickets/ 08.08.07

Flying would be have to be a lot more expensive if the anti-pollution tax were to be passed on.

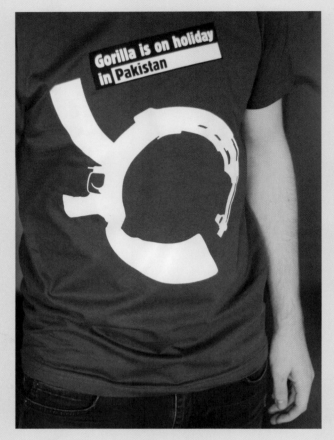

15 P	9 F	17 Cl	3 Li	8 O	26 Fe
82 Pb	6 C	1 H	53 I	11 Na	33 As
14 Si	92 U	19 K	35 Br	88 Ra	20 Ca
24 Cr	13 Al	2 He	15 P	94 Pu	81 Tl
47 A	30	16	56	7	60
8 Po	Co	W	Au	O	Cu

Heavy pollution in the Yellow River/ 16.07.07

China's Yellow River, it seems, is seriously polluted with heavy metals.

Pakistan/ 28.07.2007

Violence spirals after siege of Red Mosque in Islamabad.

THE ENVIRON- MENT BY

Gorilla

Guzzling tax/ 02.06.07

Proposal for extra tax on petrol-guzzling cars comes in for a lot of criticism.

Low-energy lightbulb is still unpopular/ 24.02.07

Despite all efforts, the amount of low-energy light-bulbs is marginal and the classic bulb continues to be popular.

Al Gore wins Nobel peace price/ 15.10.07

After Al Gore receives the Nobel Peace Prize, there is speculation about whether he will stand as a candidate.

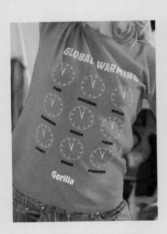

Global Warning/ 18.10.06

September was the warmest September month for the last three hundred years.

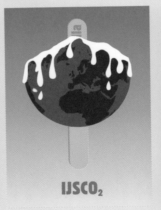

EU climate issues/ 12.03.07

The EU summit in March 2007 is completely domi-nated by climate issues.

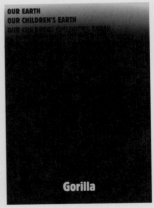

Our earth/ 25.10.06

According to the World Wide Fund for Nature we will need two planet earths if we want to continue con-suming at the same rate.

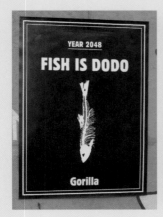

The oceans will be empty by the year 2048/ 04.11.06

Scientists predict that the oceans will be empty of fish by the year 2048. The Gorilla is referring to the extinct animal the 'dodo'.

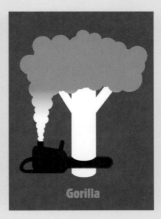

CO₂ Compensation appears to be fake/ 06.09.07

Forests planted in Africa to compensate for Western CO2 emissions appear to have been felled.

Live Earth/ 07.07.07

Al Gore and producer Kevin Wall attempt to focus attention on the climate with the Live Earth series of concerts.

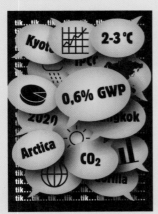

0.6 GWP/ 05.05.07

Limiting global warming costs only 0.6% of GWP (Gross World Product). In the meantime we just keep talking about it.

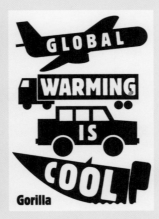

Global Warming is cool/ 18.04.07

The business world is fascinated by the environment and the climate. Opportunistic or not, if the business world behaves more cleanly then everyone benefits.

Nobel Peace Prize/ 13.10.07

Al Gore and the UN's Panel on Climate Change win Nobel Peace Prize.

No ice on the North Pole this summer.

Gorilla

JUNKIE

DEALER

Gorilla

No ice on the North Pole/ 28.06.08

Scientists predict that in the summer of 2008 the North Pole will free of permanent ice.

Protest against the high price of diesel/ 12.06.08

Protests all over Europe against the high price of diesel.

MADE IN CHINA

Gorilla

Poisonous materials from China/ 21.08.07

Poisonous materials found in various goods imported from China.

MISCEL-LANEOUS BY

Gorilla

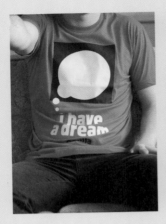

Dutch General elections/ 22.11.06

Election day

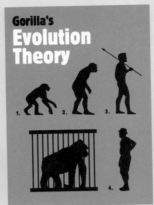

Gorilla's Theory of Evolution/ 19.05.07

A gorilla named Bokito escapes from Rotterdam zoo. We don't blame him.

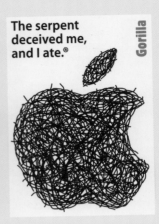

Apple introduces the iPhone/ 02.07.07

Apple launches the mother of all gadgets, the iPhone.

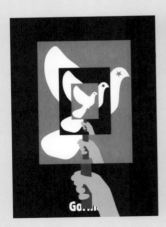

Peace protest in Turkey/ 24.01.07

100,000 people protest in favour of peace and reconciliation in the Turkish-Armenian issue.

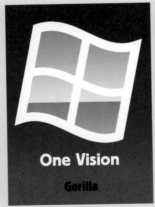

Microsoft's new operating system Vista is launched/ 30.01.07

Microsoft launches Vista, a new operating system for PCs.

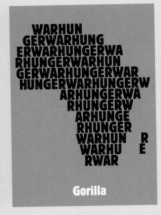

Just another day in Africa/ 29.12.06

Ethiopia bombs the airport of Mogadishu, the capital of Somalia, and carries out attacks on Islamic militants

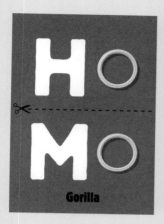

HOMO marriage?/ 03.03.07

Official resigns after refusing to comply with same-sex marriage.

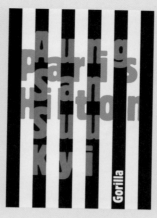

Behind bars/ 14.06.07

Paris Hilton receives prison sentence for drunk driving and is frequently in the news. Aung San Suu Kyi seems to have been forgotten.

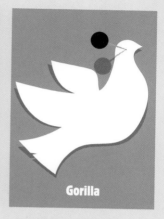

Remembrance Day / Liberation Day/ 04.05.07

A Gorilla about the Dutch Remembrance Day and the Liberation during the Second World War.

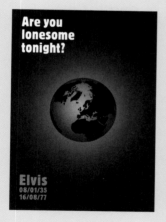

Birthday Elvis Presley/ 08.01.07

The birthday of Elvis coincides with more bad news about the environment.

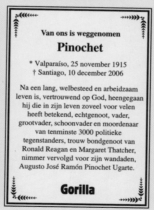

Pinochet †/ 11.12.06

A cynical death notice that was almost seen as real.

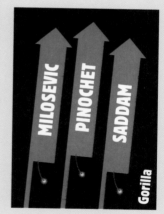

Happy new year without.../ 02.11.06

Saddam Hussein was executed on 30 December in the same year in which two other (ex-)dictators died a natural death.

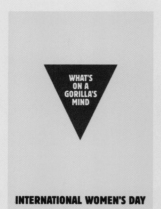

International Women's Day/ 08.03.08

International Women's Day.

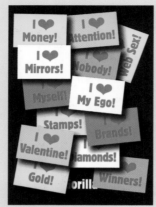

Valentine's day/ 14.02.07

Valentine's Day was just invented by shopkeepers so they could sell more.

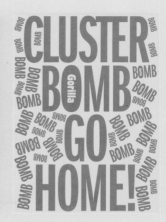

The Netherlands is removing the clusterbomb from it's arsenal/ 29.05.08

According to a new international treaty, one that has not been signed by the US, the Netherlands is also removing the cluster bomb from its arsenal.

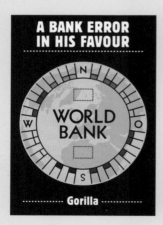

President of the World Bank accused of favouritism/ 11.05.07

Former American vice-minister of Defence Wolfowitz has to give up his position after favouring his girlfriend Shaba Ali Riza, who is also employed at the World Bank.

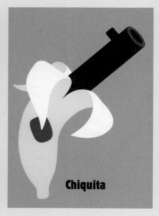

Chiquita financed private armies in South America in the '70-ies/ 24.03.07

Chiquita admits that in the past it financed death squads in Columbia.

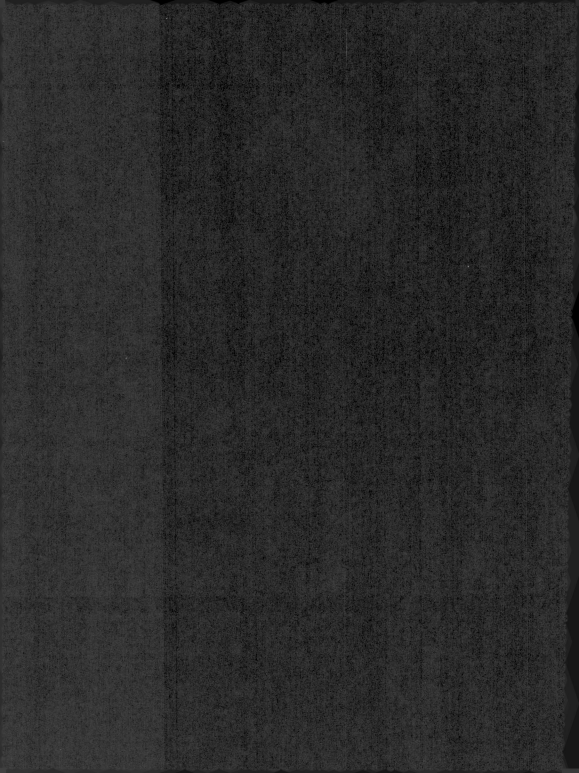

READERS REACTING ON

Gorilla

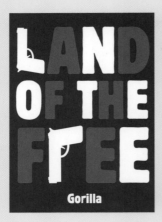

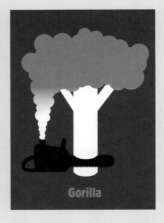

Shooting at Virginia technical university/ 17.04.07

antoinette (Elsloo)
17-04-2007 07:41
Good gorilla. If freedom can only exist through weapons it's no freedom, And then such terrible things happen.

frazi (tilburg)
17-04-2007 08:12
With today's violence you have to fight for your freedom and so it is not just criminals and 'the strong arm of the law' who have weapons.

bert (ede)
17-04-2007 11:26
For my part, they can kill each other a lot more, as long as they leave the rest of the world alone.

Karim (MSTRDM)
12-06-2007 10:44
Land of the jailed.

PKK takes pot-shots/ 23.10.07

Jonepoon (Beverwijk)
23-10-2007 07:57
Let the Turks sort it out, it's their problem. As long as they don't commit genocide!

Jennifer (Amsterdam)
23-10-2007 11:33
The PKK (fighters) and Hamas (terrorists). And what about ETA (!), Western Sahara (!), Corsica (!). In my view they're all striving for independence, but why is the one a terrorist and the other a fighter!!!

CO$_2$ Compensation appears to be fake/ 06.09.07

Erik Blodaks (Zierikzee) 06-09-2007 09:03
Precisely, and that's how it should be. Don't complain, just saw.

de Belg (Brussel)
06-09-2007 09:17
@Erik: That's how it should be? Don't complain, just saw? Jesus man, it really doesn't seem to bother you at all...

Jerry Mail (Hilversum)
06-09-2007 23:06
With my low IQ I ALMOST get it, but I pretend that I COMPLETELY get it.

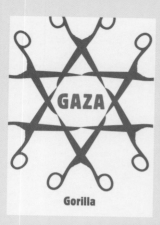

Gorilla

Closed of by Israel/ 21.05.07

antoinette (Elsloo)
21-05-2007 09:00
**I'm finding it more and
more difficult to see some-
thing positive in Israel.**

S. (Nijmegen)
21-05-2007 09:18
**Does it not count for Israe-
lis as well that you should
not kill, steal or covet what
is your neighbour's? While
this group of people have
always felt oppressed, they
themselves are now build-
ing a wall (!) and killing
their enemies. So they're
not a jot better!**

Bloemen (Hilversum)
21-05-2007 09:49
**Gorilla is simply anti-Se-
mitic. The Volkskrant has
apparently not made the
social fencing high enough.**

Yuval (Amsterdam)
21-05-2007 09:55
**The Palestinians are
certainly at it again. See
Lebanon. As far as the
wall is concerned, if you're
always being threatened
with suicide bombers,**

then surely you have to do
something to offer your
people security. Gorilla is
indeed somewhat anti-Se-
mitic, but he's not the only
one, as is shown by all the
heartwarming reactions.

S. (Nijmegen)
21-05-2007 10:09
**Why is everyone who
criticises Jewish society
always labelled an anti-
Semite? And the other way
round, if you criticise
the Palestinian idea then
you're "on the right track".
It's all so very sad. Don't
hide behind your history,
but build together on your
future!**

zorg (nl)
21-05-2007 10:31
**Europe is boycotting
Hamas, you know. known
for those bloody attacks on
citizens during the peace
negotiations and "we're
gong to destroy Israel". The
election result means that
everyone there is now the
dupe and rightly so - that's
how democracy works,
next time just don't vote for
Hamas. Call the wall self-
defence - there's nothing
"incomprehensible" about
that.**

S. (Nijmegen)
21-05-2007 11:08
**Does not the people's
right of self-determination
state that every population
group in the world has the
right to its own autono-
mous state? As yet, a large
part of the world does not
intend to recognise the
Palestinian state because
Hamas won the democratic
elections. The wall being
built by Israel is not toler-
ated by the Security Coun-**

cil, but for the time being
is not being taken down.
How can it be that on the
one hand democracy is
boycotted and on the other
hand there is no attempt
to deal with a people that
ignores Security Council
sanctions. So once again
we are seeing democracy
in this world subordinated
to other matters...

Tsja (Nederland)
23-05-2007 20:45
**The fact that a country has
not signed the non-pro-
liferation treaty does not
mean to say that it is justi-
fied in possessing nuclear
weapons. Let's be honest,
one cannot accuse Israel
of pacifism.**

Gayrilla

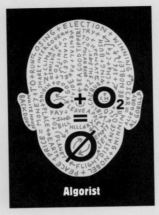

Algorist

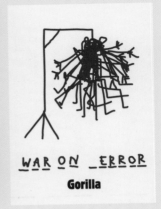

Gorilla

Polish politician: "Tinky Winky is possibly gay"/ 30.05.07

R Bosch (Arnhem) 31-05-2007 02:13
It's a bit like wondering whether Gerard Joling is gay. I'm hetero, but I have no problem with a gay Tinky Winky. That there are still cultures where the most pious village idiot runs the show ... Being religious is fine, but then surely it's a question of us all being God's children.

nella (Rotterdam)
01-06-2007 13:56
Never (not) make a fuss about sexual abuse within the Roman Catholic church but why then about a puppet meant to represent a toddler who simply finds everything nice: bags, mummy's shoes, dressing up???

Al Gore wins Nobel peace price/ 15.10.07

vdwoude (amsterdam)
15-10-2007 10:03
Al Gore is himself an enormous consumer of energy, it seems. Al Gore knows it all, but that's on his agenda. I agree with the scientists who say that global warming is a fact, but Gore has misused this for his own gain. It's very exaggerated, but he's played it well. Masses of people have become afraid. Hat's off to him.

detective (overal)
15-10-2007 10:53
Perhaps Al Gore is eligible for the Nobel Prize precisely because he has made the theme of "environment' commercially exploitable. He has shown that there's also money to be made from environmental commitment. And this was just in time.

Japan no longer participates in the "war on terror"/ 02.11.07

Ekajana (Leiden)
02-11-2007 09:40
War is error.

Arjen (Dronten) 0
2-11-2007 09:47
The more countries stop this stupid "war on terror" the better. By criminalising all sorts of countries, regimes and religions, terror simply increases.

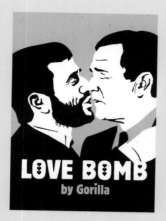

The serpent deceived me, and I ate.®

Gorilla

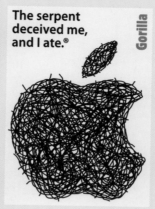

~~In het Rusland van~~ Vladimir Poetin ~~is vrijwel geen onaf hankelijke pers meer. De in de jaren negentig herwon nen persvrijheid~~ is ~~sinde het aantreden van de~~ president ~~in 1999 steeds kleiner gewor den. Journalisten worden be dreigd of vermoord en alle na~~ **Gorilla is met vakantie in Rusland**

U.S. develop new weapon: Love Bomb/ 16.06.07

Stef (Antwerpen)
16-06-2007 12:22
if only all political leaders were gay.

Apple introduces the iPhone/ 02.07.07

cor verhoef (bangkok)
02-07-2007 10:39
Who is Iphone?

Henk Boenders (den Haag)
02-07-2007 12:21
Gorilla thinks that people who have bought such an iPhone have just suc- cumbed to temptation: a pile of bling bling. Little has changed since the making of 'the first human'.

An van den burg (Lisse.) 02- 07-2007 14:12
Ah, now a lot of people's lives will be EVEN happier!

Persvrijheid/ 25.07.07

Uranium-235 (Twente)
25-07-2007 11:45
Russia has always been a dictatorship. First under the various tsars, later under the communists. It is rather arrogant to expect that we can impose our democratic values there, and that such a country will then be transformed within a few years into a Western- style democracy. We wouldn't tolerate it here if it were it to happen the other way round.tolereren.

S. (Nijmegen)
25-07-2007 12:38
So this Gorilla is about the reduction in press freedom in Vladimir Putin's Russia. Might this be because of the fact the Mr Putin feels that his power is beginning to be shaky? What can you do better than to revive old traditions in order to safe- guard your power?

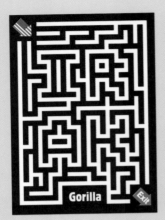

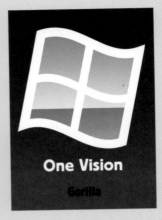

Exit strategy for war in Iraq/ 27.10.06

chiel (amsterdam)
27-10-2006 11:07
Just so long as they don't forget to take the oil with them...

allaballa (EU)
14-11-2006 21:46
there is no 'exit strategy'. no path in this labyrinth leads to the exit. the iraqis should assume more responsibility, but they are unable to do this. the freshly trained policemen lack professionalism. the mindset is too rotten! well, the democrats seem to think they know it all better. let's wait and see!

Warning of considerably higher costs of JSF/ 12.10.06

Vladimir Maksimorenoff Dugashvyilski (Dnepropetrovsk)
12-10-2006 15:17
I couldn't care less about the JSF but I don't get the joke.

Jaap (Neede)
12-10-2006 17:00
I still can't get used to the Gorillas. They are so different from what previously appeared in the bottom right corner of the front page. So...

mr. goodman (Heelsum)
13-10-2006 10:45
People who don't get this must be very stupid. Doesn't it clearly say JSF on the aeroplane's wings. And let's be honest, Campert's Mallebroodje was not a particularly 'brilliant' discovery. Yes people, Gorilla demands a bit more early morning thought. Keep on going, big ape.

Microsoft's new operating system Vista is launched/ 30.01.07

Derek Groen (Amsterdam)
30-01-2007 18:56
I don't know what that window is meant to represent, but it's not a correct representation of Windows Vista.

Niels (Groningen)
04-02-2007 16:21
One Vision indeed - that of Apple Inc FIVE years ago! Deplorable.

Patrick (Brunssum)
08-02-2007 18:44
Vista. Just purchased! Tip for everyone: don't copy me. What a heavy programme. software like Autocad, old version of office and suchlike no longer work. New versions have to be purchased. What a drag. Regret, regret, regret. My next OS will certainly be MAC.

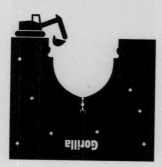

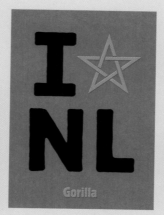

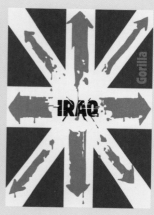

Unrest after Israel starts digging at temple mountain/ 10.02.07

HJ (Groningen)
10-02-2007 15:12
Israel is the country with the most UN resolutions to its name. They refuse to comply with them or America declares its veto. After the brutal war in Lebanon there are still 1 million cluster bombs lying around. The Palestinians have been oppressed for 50 years. Israel is a nuclear power that has not signed the non-proliferation treaty. Any other country that ignored so many resolutions and did not sign the non-proliferation treaty would have great problems internationally. Iran has signed the treaty and allows inspections by the International Atomic Agency, but is now under enormous international pressure. They are even being threatened with mini-nukes. In my view this is applying double standards. Of course it leads to protests in Muslim countries.

Patriotism/ 16.02.07

Peter (Amsterdam)
16-02-2007 09:57
I also fear that the loyalty of the moroccan "Dutch" will not lie with the Netherlands.

DIVANO (Bodegraven ^zh^)
16-02-2007 10:17
Yet another example of narrow-mindedness and Wilders-like ideas, it's unbelievable. If you're born here as a moroccan and had the luck or bad luck to attend a catholic school (obligatory prayers), you can still be loyal to the Netherlands. Stop marginalising people!!!

kees (ergena)
16-02-2007 17:31
Wilders is right - Aboutaleb is not at all to be trusted. No foreigners with double passports in the government.

British troops leave Iraq/ 22.02.07

Baron Z.d.C. (den haag)
22-02-2007 11:57
1. Another gorilla as Green-Left propaganda department. No depiction of decapitated, blown up children and bloodshed caused by the militias and suicide bombers. 2. The westerners, adopting the attitude of Disneyland humanitarians, came there with "precision strikes"; result: the enemy kept its power intact. 3. the mistake was to attack Saddam instead of IRAN. 4. T. Blair, ultimately an opportunist. 5. Gorilla's space is the Café of the trembling one-eyed persons of the Pacifist church. Wait and see.

vos (010)
22-02-2007 12:00
Wow, the Baron should long ago have taken his anti-psychotic pills, take them quickly Baron! Good gorilla, btw...

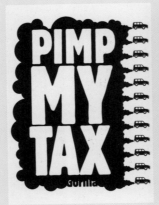

Japanese "comfort girls" during WW II/ 17.03.2007

Olav (thuis)
17-03-2007 10:26
Disgusting and certainly not funny.

Bertus (Noordoostpolder)
17-03-2007 12:51
The land of the rising sun feels no guilt or shame so a loincloth could have just as easily have been used.

Jesse Kolk (Amsterdam)
18-03-2007 11:05
Volkskrant, the level of the gorillas is already so pathetically low, so why place all these pitifully complaining reactions as well? What aim do they serve? If this is what the VK means by interactive...

D. van Dale (Amsterdam)
18-03-2007 11:28
Jesse Kolk, you shouldn't complain...

Guzzling tax/ 02.06.2007

mike (leidschendam)
02-06-2007 10:22
The show-offs driving SUVs won't be put off by this, I think. If you can afford 75,000 Euros (!) for a car then you're also prepared to pay a bit more.

Jan Grenner (Kijiv) 02-06-2007 11:43
If you can afford a SUV then you can easily pay more tax. Unfortunately this is the very reason why this measure will solve nothing. Ok, the state gets a bit more income, but the trouble caused to the environment and road safety by these monsters will not disappear. Better to ban the SUVs from the city and to suspend the driving licence for five years - unconditionally - for those who break the law.

Heavy criticism by U.S. allies/ 04.09.07

vdwoude (amsterdam)
04-09-2007 10:55
Soon Bush will be gone. They call that democracy. If you've any idea how big America is, then there's still the other half with umpteen millions of Americans who did not want this. I'm glad the Americans are there, what a disaster it would be with these weak Europeans and fellow-travellers.

cor verhoef (bangkok)
04-09-2007 11:10
vdwoude; Bush may well leave in 16 months, but very little will change. It makes little difference who is in power in the US. And as far as democracy goes; Up until now the election has always been won by the presidential candidate with the highest budget. Such an interpretation of "democracy" brings no tears to my eyes.

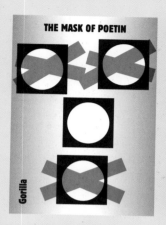

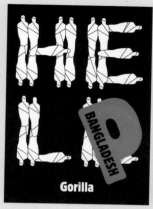

Presidential elections in Russia/ 07.12.07

Karl (R'dam)
07-12-2007 10:01
It is true that more than 70% of Russia trusts Putin and worships him. It is also fine that Vladimir has pulled Russia out of an enormous abyss. But, as always, it seems that power corrupts.

Ferrie Veen (Rotterdam)
07-12-2007 10:50
A mask presupposes an (underlying) secret. Well then, in Putin's case it's clear: How Do I Remain in Power. That's his obsession

Floods in Bangladesh/ 21.11.07

ZZZ (ZZZ)
21-11-2007 16:18
It makes no difference where you live! Woe upon woe; war upon war, epidemic upon epidemic, famine upon famine! Luke 21:11 And there will be great earthquakes, and in various places plagues and famines; and there will be terrors and great signs from heaven.

harald ton (beijing)
21-11-2007 16:23
Surely it can't be true? Damn, put up my policy fast.

Peter (Zaandam)
21-11-2007 22:48
If the solidarity among the Muslim brethren is as great as it should be on the basis of the book, billions of petrol dollars should soon be rolling in.

Pakistan bids farewell to Benazir Bhutto/ 29.12.07

harald ton (beijing)
29-12-2007 18:16
More than 40% of Pakistanis have no problem with the points of view of the Taleban, to put it mildly. A woman, one moreover with a Western education and calling for democracy and equal rights for women, turns up and finds herself in a relatively unprotected situation, what do you think happens then?

Katja (Amsterdam)
29-12-2007 18:58
Hi Harold, I also saw and understood it from this angle. In other words, she did not know her Pakistani people well enough and in any case you don't impose a Western leader onto a Muslim country. It could just as easily have been 1 male determined to commit suicide.

De Designpolitie
De Designpolitie was founded
in 1995 by Richard van der
Laken and Pepijn Zurburg,
both of whom studied at the
Hogeschool voor de Kunsten
Utrecht and the Sandberg
Institute in Amsterdam.
Among De Designpolitie's
recent clients are TNT,
Interpolis, Stadsschouwburg
Amsterdam, Artis, the
Netherlands Architecture
Institute (NAi) and Galerie
W139. De Designpolitie's
work has been nominated
and awarded prizes by, among
others, Stichting De Best
Verzorgde Boeken, The
Rotterdam Design Prize, the
British A&AD and the Japanese
PEN. De Designpolitie has
taught at the Hogeschool
voor de Kunsten Arnhem, the
Hogeschool voor de Kunsten
Utrecht and AKV/St. Joost in
Breda. They have also given
workshops and lectures in
the Netherlands and abroad.
The monograph The ABC of
De Designpolitie is appearing
in 2008.
> www.designpolitie.nl

Herman van Bostelen
Immediately after graduating
from the Hogeschool voor
de Kunsten Utrecht in 1996,
Herman van Bostelen set
himself up as a freelance
designer in Utrecht. Since
then he has worked for such
clients as 't Barre Land,
Theater Kikker, Springdance,
the Zeeland Nazomerfestival,
KPN and TNT. In 2005 he won
the theatre poster prize for
his poster for 't Barre Land's
Mauerschau. Herman van
Bostelen taught typography
and graphic design at the
Hogeschool voor de Kunsten
Utrecht from 2001 until 2007.
> www.hermanvanbostelen.nl

Lesley Moore
The Lesley Moore design office
was founded in 2004 by Karin
van den Brandt and Alex Clay.
The two designers graduated
from the Hogeschool voor
de Kunsten Arnhem and
received a starter stipend from
the Netherlands Foundation
for Visual Arts, Design and
Architecture. Besides Gorilla,
Leslie Moore works for the
architecture magazine Mark
Magazine, VPRO 3voor12 TV,
Galerie Wilfried Lentz and the
Centraal Museum in Utrecht.
> www.lesley-moore.nl

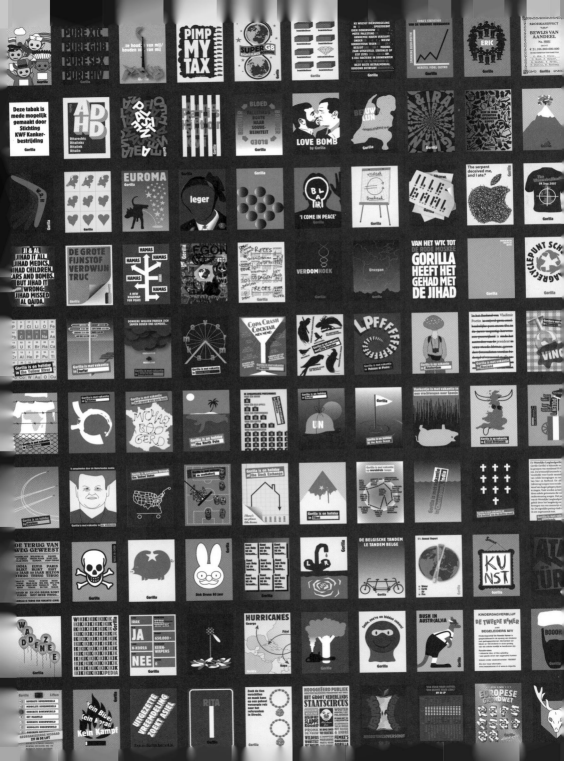